LOGOS REDESIGNED

How 200 Companies Successfully Changed Their Image

LOGOS REDESIGNED
How 200 Companies Successfully Changed Their Image

David E. Carter

HARPER
DESIGN
An Imprint of HarperCollinsPublishers

LOGOS REDESIGNED
Copyright © 2005 by HARPER DESIGN and David E. Carter

First published in 2005 by:
Harper Design
An Imprint of HarperCollins*Publishers*
10 East 53rd Street
New York, NY 10022
Tel: (212) 207-7000
Fax: (212) 207-7654
HarperDesign@harpercollins.com
www.harpercollins.com

Distributed throughout the world by:
HarperCollins International
10 East 53rd Street
New York, NY 10022
Fax: (212) 207-7654

HarperCollins books may be purchased for educational, business,
or sales promotional use. For information, please write:
Special Markets Department
HarperCollins Publishers Inc.
10 East 53rd Street
New York, NY 10022

Book design by Designs on You!
Suzanna and Anthony Stephens.

Library of Congress Control Number: 2004117614

ISBN: 0-06-074805-2

Printed in China by Everbest Printing Company through
Four Colour Imports, Louisville, Kentucky
First Printing, 2005

"Why change a logo?" To people who are not in the design or advertising world, this seems to be a fair question.

Why replace a suit that you bought 15 years ago? Why replace your Apple II computer? Why replace the Compugraphic you bought? Why replace your old car?

Products wear out and become ineffective. So do logos. The logo that was very appropriate for a company in 1960 no longer works today because:

a. the company no longer sells the same products.

b. the market has completely changed.

c. the competition has become more aggressive, and their logo makes your corporate image pale in comparison.

d. the old logo was very "stylish" in 1960; now it is tired.

The list could go on. When a company has a different product line, a different marketing strategy, or new and more aggressive competition, the old logo can become negative very quickly. And when the logo becomes a negative, it must be changed. The big question is **how much change is needed**?

There are two basic approaches to logo change. One is a small change, in which the old logo is used as a foundation for the new design. This is **evolutionary** design. You will see many examples of this kind of change in this book.

But, there are times when the old logo is no longer something to be built upon, and the new logo bears absolutely no relationship to the old one. This is **revolutionary** design, in which the old logo is swept into the archives and a totally new design results. Possible reasons to do this are:

a. the company has changed substantially, and the old logo is linked to the past. An example is Ashland Oil, which once was a major oil refiner and marketer, with thousands of gas stations over much of the country. The company sold its refining capacity and service stations, and gravitated toward the chemical market. The logo change was revolutionary and was absolutely the right change.

b. the old logo was bad and had no redeeming design value. The only way to get design excellence is to scrap the old logo.

In some cases, the logo is not all that needs to be changed. Sometimes, the name of a company must be changed. This is a drastic step and many things can make it necessary. One example is in this book. A company formerly known as *Ground Zero* changed its name after September 11 because of the new meaning associated with their former name.

So, there are some very good reasons why logos need to change. In this book, you will see 200 recent examples of logo redesign. Best of all, each example has a brief commentary on the project, most of which were written by the designers themselves.

So, if you are about to begin the logo redesign process, here is information that will make the job much more productive.

This National Football League team needed to get rid of their vintage logo and hired Evenson Design Group to bring a more sophisticated and sleek image to represent their team's identity.

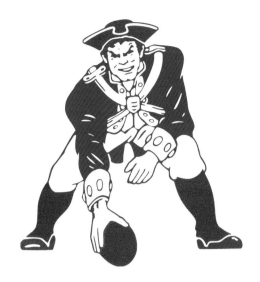

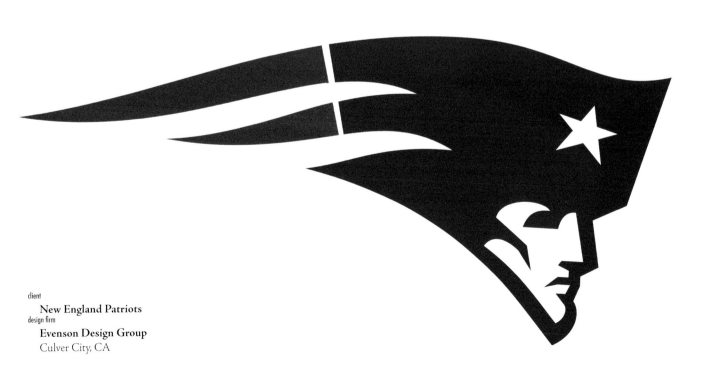

client
New England Patriots
design firm
Evenson Design Group
Culver City, CA

This is a redesign of retail identity for designer and potter Jonathan Adler. The new identity is based on his "Mother and Child" fabric design, and exhibits the spirit and personality of the designer and his work.

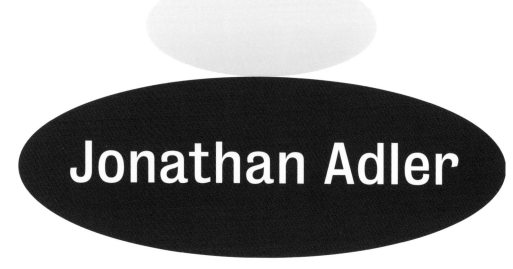

client
Jonathan Adler
design firm
Alexander Isley Inc.
Redding, CT

Prior to hiring Rickabaugh Graphics, Ohio State athletics had been represented by countless variations on the traditional "Block O" (including a "Script O" for the women's teams). The school asked us to establish an official "Block O" with something that identified it as belonging to "Ohio State". The selected design perfectly represents the over-100 years of athletic tradition at Ohio State University and features a custom designed typeface that is permanently incorporated into the design.

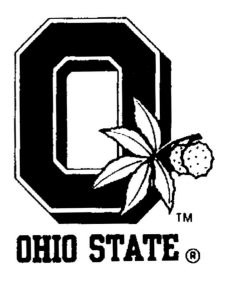

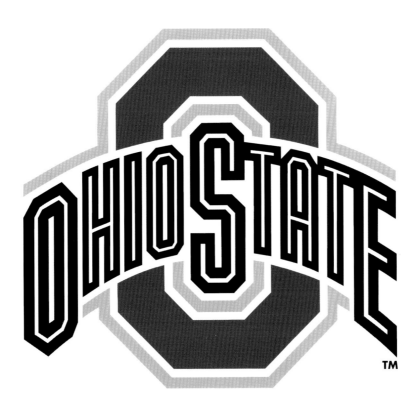

client
Ohio State University
design firm
Rickabaugh Graphics
Gahanna, OH

Hornall Anderson, a design focused branding company, wanted a new look for their identity that would transition better from something that could eventually become dated. The redesigned identity had a wit to it; the design of a capitalized "A" with the top chopped off to also form the letter "H".

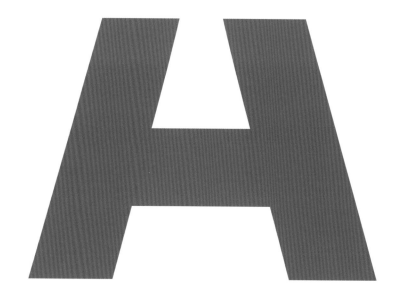

client
Hornall Anderson Design Works
design firm
Hornall Anderson Design Works
Seattle, WA

The objective was to amplify Post's brand symbols (the logo, the associated imagery, and package format) while allowing individual subbrands to shine through. Research confirmed that the new Post design platform makes the brand more potent, engaging, and relevant...in short, more reflective of the brand's small-company, caring posture. The new "Postmark" features greater dimensionality than before, reflecting the more handcrafted, quality-driven ethos that drives the brand.

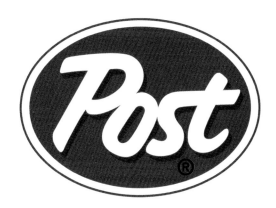

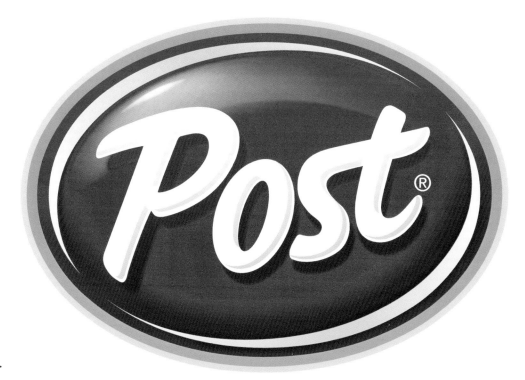

client
Post
design firm
Source/Inc.
Chicago, IL

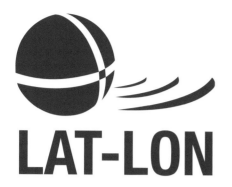

LAT-LON provides rugged, self-powered, wireless monitoring and GPS tracking devices to transportation and heavy equipment industries. The company name comes from the "latitude" and "longitude" components of the GPS tracking services.

The old logo had been designed to have a global look, with telemetry symbols, but was easily mistaken for a beach ball. The typeface for the company name lacked any style or size relationship.

The new logo, with tapered lines on the "globe" coming to a point and telemetry waves emanating from that point give the logo a 3-D look. The company name, which is now in a unique typeface, is encircled by the waves, which appear to push the company name to foreground and pull everything together.

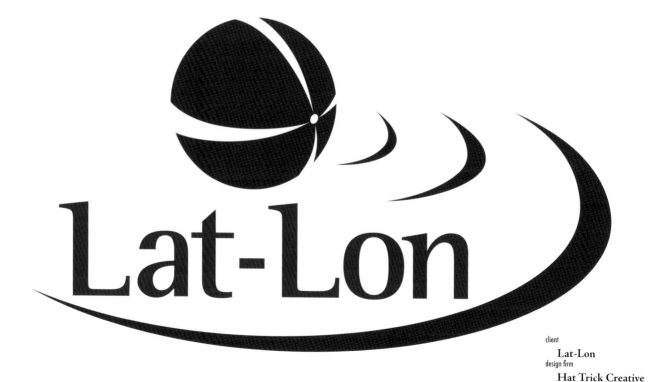

client
Lat-Lon
design firm
Hat Trick Creative
Littleton, CO

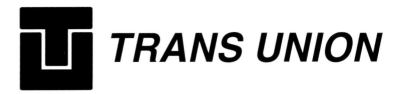

TRANS UNION

TransUnion is an information company which primarily compiles data about an individual's credit history. Recently, TransUnion's competitors completed branding programs and TransUnion needed to update their image to remain competitive.

Research indicated that the public felt credit history companies like TransUnion were "big brother," secret, and unfriendly. This was supported by TransUnion's old industrial-looking logo. One of the goals of the re-branding was to present the company as being more accessible—a partner, not an enemy, of the customer.

The logo illustrates this. The data, represented by the "T" made of dots, intersects with the gray "T," representing a person. The logo, along with a comprehensive brand implementation program, revitalized the company, updated its image, and gave it a much more customer-friendly image.

TransUnion

client
TransUnion
design firm
Silvester + Tafuro
South Norwalk, CT

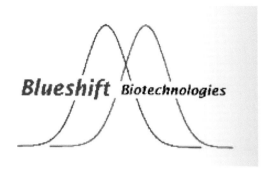

The Blueshift technology focuses on blue laser lights which scan cells for life sciences research. In creating the new identity, light waves of the original logo were simplified, and with a tighter crop, looked more contemporary. Once tilted, the waves resembled the initial "B." The logo reflects the product's feature of streamlining the process of drug discovery screening techniques.

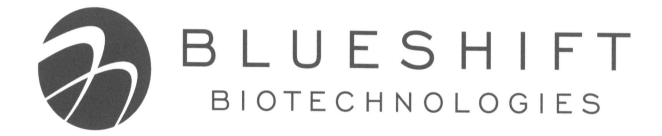

client
Blueshift Biotechnologies
design firm
Laura Coe Design Associates
San Diego, CA

The original logo was created for materials sent out to find a full-time job at a graphic design firm. The "A", combined with the nut graphic, depicted the "Design Nut" concept. Using the first letter of my last name (Almond) focused more on me as an individual.

Once I started doing more work on my own, I decided to set up Design Nut as a company, working for myself exclusively. To help market Design Nut, I changed the logo's focus by making it a combination of a letter "d" and the nut graphic. I was able to drop my name from the logo making the identity cleaner.

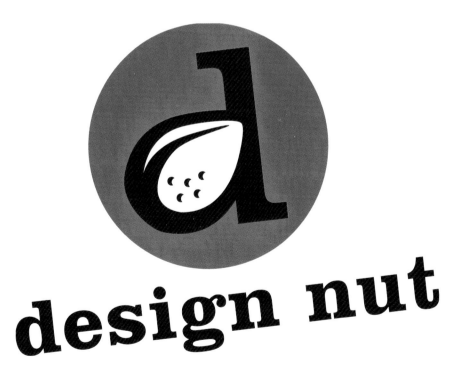

client
Design Nut
design firm
Design Nut
Kensington, MD

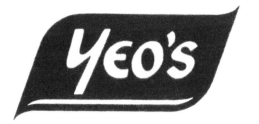

People in 60 countries consume Yeo's beverages and foodstuff, a brand boasting over 103 years of quality and heritage. With the new logo, Ukulele Brand Consultants was mindful of respecting the goodwill associated with the brand, while also presenting a new design representative of the company's desire to endear itself to a wider, more youthful audience. The new brand identity is indicative of an updated, modern mindset, exemplified by a livelier typeface and a free-form shape resembling a water droplet—able to reshape and reinvent itself—much like Yeo's ability to constantly evolve. While all this is achieved, the same background red that is synonymous with Yeo's is maintained to create the same affinity and immediate recognition with the consumer.

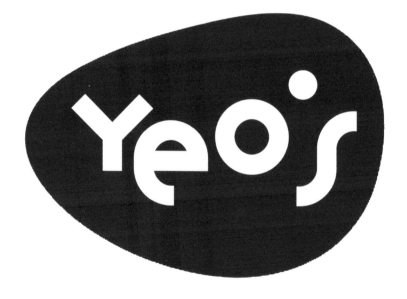

client
Yeo
design firm
Ukulele Brand Consultants
Singapore

Like many churches and non-profits, Colonial Beach Baptist Church has little marketing budget, so their "logo" ended up a drawing of the church donated by a member, coupled with some stock script font.

The new logo also used an image of the church structure, since it is very recognizable in the community. But it focused on the steeple, and simplified the illustration style to make it stronger and more iconographic. In addition, to emphasize the church's slogan "A Lighthouse for God", a light burst graphic was added.

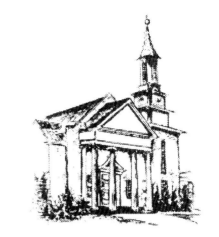

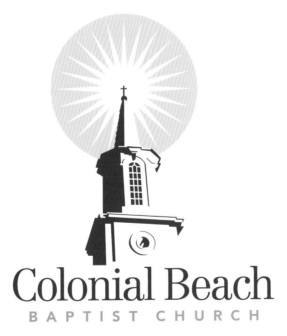

client
Colonial Beach Baptist Church
design firm
Design Nut
Kensington, MD

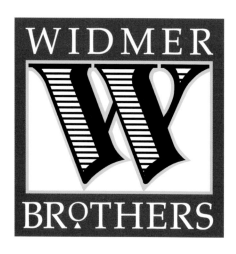

Widmer Brothers Brewery first started their business in 1984, currently distributing their product primarily throughout Oregon, but also in Washington, Idaho, California, Wisconsin, New York, and Ohio. They approached Hornall Anderson with a packaging redesign and re-branding project.

Hornall Anderson evolved the client's logo from its dated look to more of a mark that emphasized the history of beer, including wheat, hops, and the client's filigree. Heritage and craftsmanship were stressed as more of a "back to basics" look and feel.

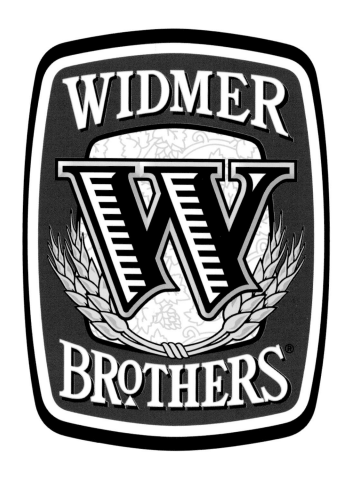

client
Widmer Brothers Brewery
design firm
Hornall Anderson
Design Works
Seattle, WA

This identity redesign was for a company that partners with home builders, providing interior finishing. The original logo was created using a formal type treatment, but did not reflect the spirit of the company or the services it offered. The revised flexible identity system is modular, suggesting tile and construction.

client
Creative Touch Interiors
design firm
Alexander Isley Inc.
Redding, CT

As an established lighting company, CJS wanted a new logo, contemporary but not too trendy, that targeted a market consisting mainly of architects and engineers. A sense of symmetry and growth was created through the typography and light rays imagery. The tall font works well when the logo is reduced on the product labeling.

client
CJS Lighting
design firm
Laura Coe Design Associates
San Diego, CA

In addition to a new logo, this gay rights advocacy organization was changing their name as well. Showing a scales of justice over a triangle (a commonly used symbol for the gay and lesbian community), the original logo was very dated and cliche. Virginians for Justice changed their name to Equality Virginia, in hopes of projecting a more inclusive, modern, and less antagonistic image. To reinforce these desires, the new logo is a bold, modern graphic that includes an equal sign embedded in the type.

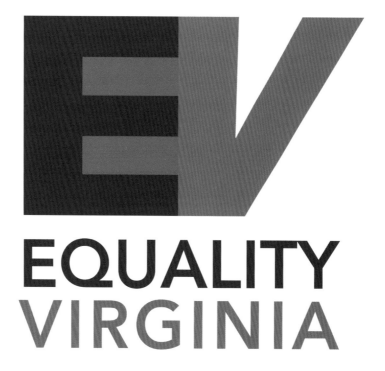

client
Equality Virginia
design firm
Design Nut
Kensington, MD

Originally named Passport Nails, this firm planned on offering nail care services in airports.

It soon became clear that they needed a complete repositioning, and they were renamed Passport Travel Spa. The comprehensive branding program included logo, website, collateral materials and store design.

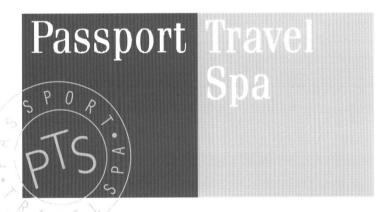

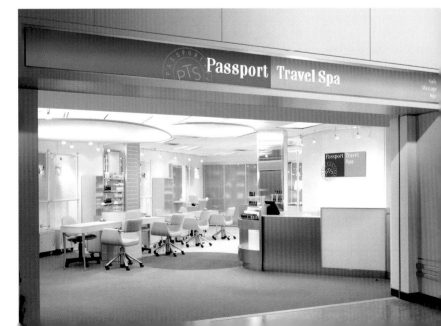

client
Passport Travel Spa
design firm
Silvester + Tafuro
South Norwalk, CT

This identity redesign was for a suite of specialty software for the architecture and interior design community. The original logo showed a bolt of fabric, with nothing said about BlueBolt's services. The new logo evoked the method of constructing a sample board, which is exactly what the software product allows interior designers and architects to do at their computers. The four boxes pieced together also represent the sample layout of swatches.

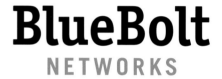

client
Blue Bolt Networks
design firm
Alexander Isley Inc.
Redding, CT

COUP & SMITH ARCHITECTS

This logo was redesigned to represent the upscale style of the architects of Coup Smith Diaz. Since the architects design many government buildings and schools, primary colors were used as the building blocks of their logo.

Coup | *Smith* | *Diaz*

ARCHITECTS

client
Coup Smith Diaz
design firm
Laura Coe Design Associates
San Diego, CA

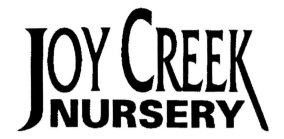

The old logo simply didn't convey the image of a high-end specialty nursery. Expressing concern about introducing a "new" logo after having been in business for some time, the client was shown that a "revised" design could maintain a sense of the existing brand, while projecting more professionalism.

The new logo, using a more elegant type, still says "Joy Creek Nursery" to the firm's clients and vendors. The flowing form between the words hints at the actual creek flowing through the nursery property when presented in blue, and conveys an image of the rolling hills of the area when the logo is printed as a one-color design in green.

client
Joy Creek Nursery
design firm
Jeff Fisher LogoMotives
Portland, OR

Caribbean Food Delights is a food distribution B2B company located in New York City. For more than 20 years, they have sold Caribbean food to stores throughout the USA.

Because of the increased demand for their unique and exotic food, they believed there could be a large mainstream market available if they developed a franchise. The components of the new identity were name, logo, and store design.

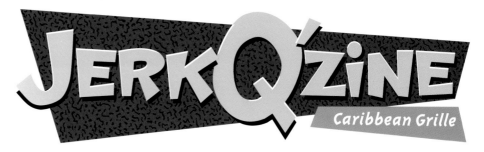

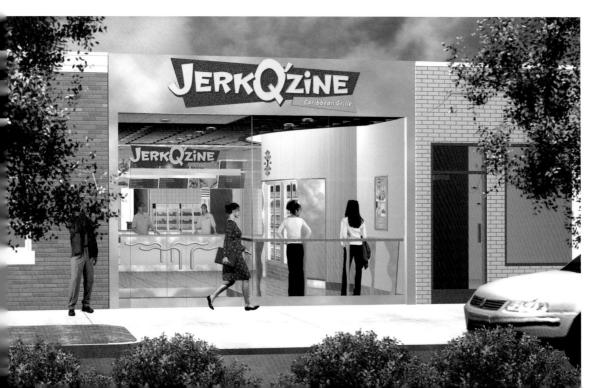

client
Jerk Q'zine
design firm
Silvester + Tafuro
South Norwalk, CT

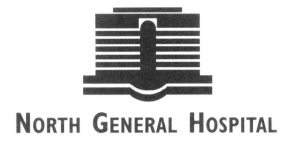

North General's logo had served them well in the Harlem, NY, community they served. However, the logo, which depicted the building facade, meant nothing to those beyond the area. The typography and style of graphic were also dated.

As part of the "Harlem Renaissance" that is taking place, with many new businesses and investors entering Harlem and South Harlem, North General had received major funding to renovate their structure and their marketing materials.

In order to appeal to new residents and physicians outside Harlem, the new logo took the focus off the building, projecting a more modern, sophisticated image. The "N" is for "North," but also alludes to the Manhattan location with the three bars on the "N" representing the skyline. The bars serve as a depiction of technology and upward movement as well.

client
North General Hospital
design firm
Design Nut
Kensington, MD

COMDIAL®

After overhauling its product offerings, Comdial's new management wanted focus on improving its corporate image. Comdial's objectives included retaining the corporate equity the company had built over 25+ years, while also attracting new partners and a new customer base by demonstrating innovation and an emphasis on leading edge technology.

COMDIAL
A World Connected

client
Comdial
design firm
Keen Branding
Charlotte, NC

The original logo for this balloon delivery service and gift/card retailer, Balloons on Broadway, had served the company well but did not convey much about the business itself. As more customers began to refer to the company by its initials, B.O.B., the owners decided to have a new identity created. The new logo, with the inclusion of a balloon graphic, projected much more of the fun and energy of the business and the individuals running the company. The colors for the firm remained black and white.

Later, a move to a new location, as well as introducing the business to the Internet, another update of the company image was in order. An unrelated local business had started using a "BOB" advertising campaign so Balloons on Broadway opted to move away from that reference while maintaining much of the previous logo's appearance. Color was added, which could also translate well to a web presence and neon signage. The colors could be manipulated to signify various holiday promotions. The logo was still often presented in black and white, tying into the previous branding of the business.

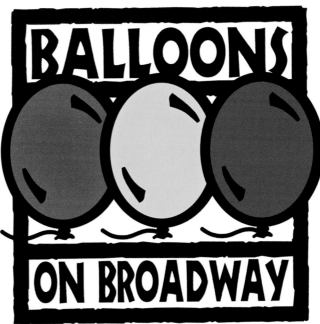

client
Balloons on Broadway
design firm
Jeff Fisher LogoMotives
Portland, OR

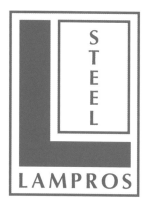

For decades, Lampros Steel, a metals distributor, used a logo incorporating a large simple "L" as the company's identifying symbol. Within the logo, which was often printed in reflex blue, the name did not seem to read properly.

A new logo was designed again making use of a large "L" as the primary element. This time the letterform took on the shape of a stylized steel beam with gradations giving the symbol the appearance of reflective metal. A stronger font was introduced.

The "L" is now a recognizable identifier for the company as a stand-alone graphic. When reproduction specifications make gradations impossible, the "L" may be presented in solid black or gray.

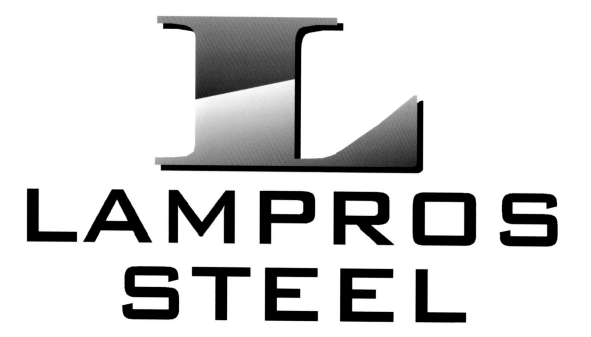

client
Lampros Steel
design firm
Jeff Fisher LogoMotives
Portland, OR

The existing SnorkelPro subbrand needed a more current look that worked well on products as well as in print. The new logo was designed using a water bubbles visual to connect the consumer to the sport.

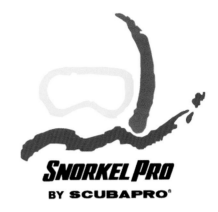

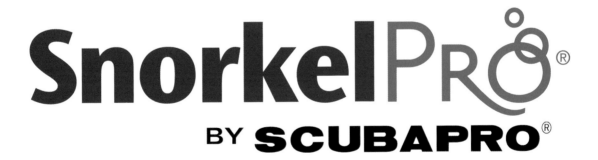

client
SnorkelPro
design firm
Laura Coe Design Associates
San Diego, CA

In this case, the old logo—for what was then the law firm Smith Freed Heald & Chock—was actually a new identity that had been approved and implemented by the company. There was only one serious problem. The letters representing the names did not really read in the order they should due to awkward placement in the design. Prior to dedicating money for a cast bronze lobby sign, the partners in the firm decided to have the logo redesigned.

Ampersands are always odd design elements in "alphabet soup" company identities. It was decided to eliminate the symbol completely and just include the initials of the partners in a simple logo. To keep the costs of reproducing all printed materials to a minimum, the logo was limited to a one-color treatment at the time.

A change in the name of the firm to Smith Freed Chock & Eberhard required that the logo be changed to incorporate the acronym SFCE. A new, two-color palette was introduced to set the image apart from the previous incarnation.

Yet another name change resulted in additional alterations to the logo—and the reintroduction of the ampersand.

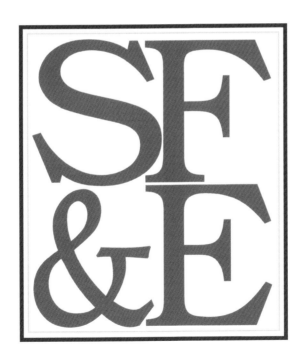

client
Smith Freed & Eberhard
design firm
Jeff Fisher LogoMotives
Portland, OR

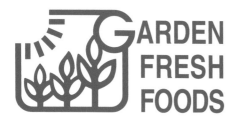

A provider of fresh-cut, high-quality produce, Garden Fresh Foods targets high-end chefs at upscale restaurants. Its logo, however, had a juvenile feel to it, and the marketing materials looked like menu pictures in the windows of Chinese restaurants.

The new logo retains the sun rays to convey growing plants, but the "Garden Fresh" element is emphasized. The idea behind the simplistic plants in the original shows up in the new logo in the form of a leaf motif in the font. The new marketing materials make the appetizing food the star, and position the company to be taken seriously by serious chefs.

Garden Fresh
FOODS, INC.

client
Garden Fresh Foods
design firm
Walsh Design
Seattle, WA

The museum, devoted to the history of film and video, had an all-type treatment, with no symbol. The logo was redesigned to show the initials of the museum broken into four quarters, the way a camera lens sections off a subject. In addition, an eye symbol was created for the "I."

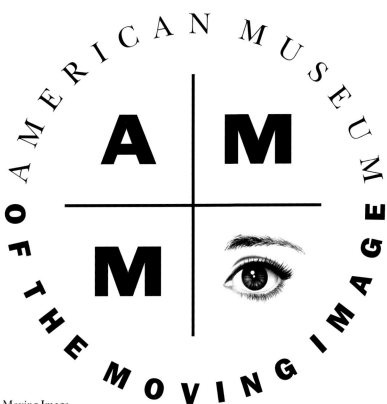

client
American Museum of the Moving Image
design firm
Alexander Isley Inc.
Redding, CT

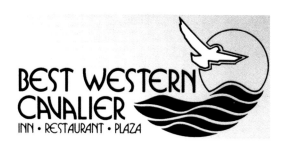

Dating from the early 70s, the previous logotype, though well intended, lacked the elegance embodied in the property it represented. The new image attempts to capture the spirit of the ocean as it pounds the shore at the southern gateway to California's Big Sur Coast. Loose calligraphic letterforms contrasted with more controlled support type to complete the image.

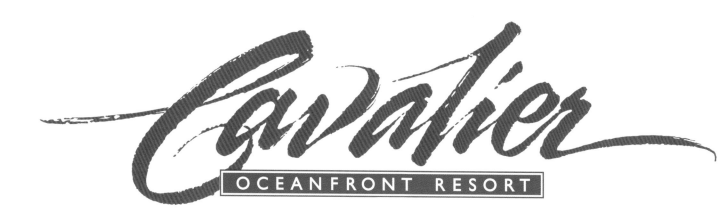

client
Cavalier Oceanfront Resort
design firm
Pierre Rademaker Design
San Luis Obispo, CA

The old Sienna Graphics logo was a simple type treatment with no distinction. We created a logo that tied into the quality production and genuine, old world service they offer.

Sienna Graphics Inc.

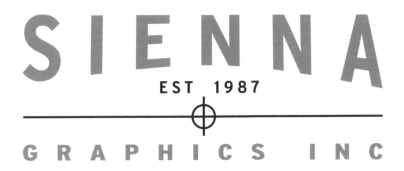

The old Señor Roof logo was an indistinct type treatment. We created a logo that portrays craftsmanship, tradition, and stability.

Señor Roof, Inc.

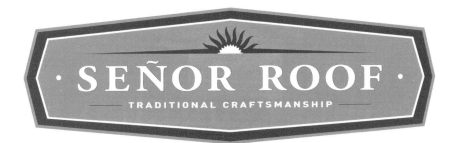

EQUITY MARKETING, INC.

11444 W. OLYMPIC BLVD. SUITE 300

LOS ANGELES, CA 90064

Equity Marketing is a manufacturer and distributor of licensed toys. The redesigned identity system was created with an eye toward reflecting the playfulness of the client's products.

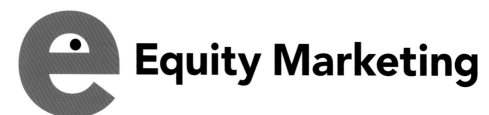

client
Equity Marketing
design firm
Alexander Isley Inc.
Redding, CT

The old logo was very scientific and frankly, kind of scary. We created a logo that is approachable and portrays a sense of caring.

RETINA
CONSULTANTS
of Southwest Florida

Retina Consultants
of Southwest Florida

client
Retina Consultants
design firm
Cave Design Agency
Boca Raton, FL

With a graphic image that dated from the 70s, Ann's was anything but contemporary. Catering to young professional women, Ann's needed to revisit its entire visual personality. The new logotype was part of a comprehensive update that included interior design, merchandising design, architecture, and signage. A fresh, optimistic, and spontaneous mood was created with the loose, calligraphic letterforms. Very precise Bodoni typography adds a tailored contrast for visual interest.

Ann's
Contemporary
Clothing

San Luis Obispo,
Paso Robles,

California

client
Ann's Contemporary Clothing
design firm
Pierre Rademaker Design
San Luis Obispo, CA

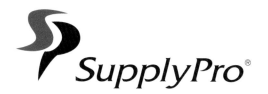

SupplyPro, a web-based inventory management company wanted a logo that was as innovative as their product. A customized font and an element of connectivity were used to represent the linking of the suppliers to the SupplyPro system.

SupplyPro®

client
SupplyPro
design firm
Laura Coe Design Associates
San Diego, CA

Tel-Med is a free medical help-line service, offering prerecorded messages in answer to a wide variety of basic medical questions. The old logo consisted of an illustration of an antique-style phone next to the name. The phone image did not successfully convey the modern capabilities of the system and a new image was requested. The new graphic identity for Tel-Med incorporated a stylized human form, as a medical professional, and the push buttons of modern phone equipment. The symbol can be used without text and still convey the purpose of the service.

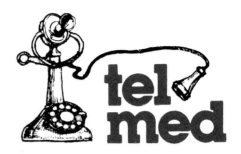

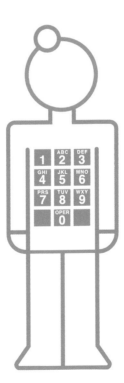

client
Tel-Med
design firm
Jeff Fisher LogoMotives
Portland, OR

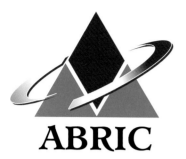

The new logo is formed with three arrowheads projecting outwards in an elliptical course to denote growth and movement. The four primary colors of red, blue, green, and yellow are dynamically diversified to show that Abric is an organization pursuing global businesses.

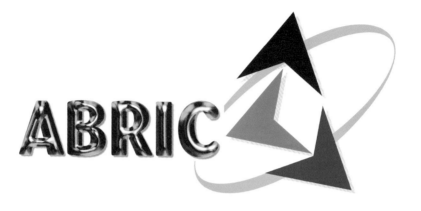

client
Abic
design firm
TrueFaces Creation
Selangor, Malaysia

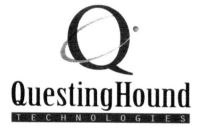

The old Questing Hound logo had a similar look to many other tech companies within their field. We created a logo that is more distinctive with an approachable, welcoming feel.

QuestingHound
technology partners

client
QuestingHound
design firm
Cave Design Agency
Boca Raton, FL

The old logo was derived from clip art and did not reproduce well. We created a modern logo that represents the quality and freshness Southern Specialties offers, as well as their forward-thinking approach.

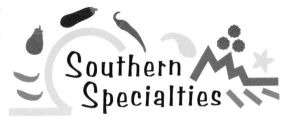

client
Southern Specialties
design firm
Cave Design Agency
Boca Raton, FL

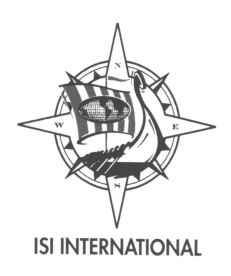

ISI INTERNATIONAL

Icicle Seafoods, Inc., markets a variety of Alaskan seafood products. With year-round processing facilities in Alaska, they are a leader in their industry. ISI International, a division of Icicle, was established to source and market shrimp originating in Asia. Their initial logo was an attempt to add a more global symbol (a compass) to Icicle's Viking ship logo. The result was ineffective. The new logo communicates the tie to Asia with an Asian-style dragon. The dragon, as a product brand, will attract attention to the product and contribute to building brand loyalty.

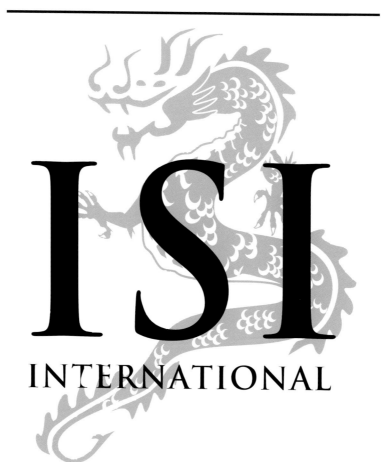

client
ISI International
design firm
Walsh Design
Seattle, WA

DEN-MAT, INC.

Den-Mat, a manufacturer of professional dental products and restoratives was experiencing global growth and needed to update its image. The new logotype was designed to embody the strength and stability exhibited in their products. The hyphen is depicted as a "bond" between the two words, serving as a symbol for the physical characteristic upon which most of their materials are based.

Den-Mat®

client
Den-Mat Corporation
design firm
Pierre Rademaker Design
San Luis Obispo, CA

Boasting of a history that spans from the mid 1920s, the Lodge has long been a California landmark in the pine forest of Cambria by the Sea. The previous logotype stopped short of capturing the mystique of the Lodge's past. Period travel brochures, luggage labels and advertisements inspired the new identity, which is designed to look as though it existed from the beginning.

client
Cambria Pines Lodge
design firm
Pierre Rademaker Design
San Luis Obispo, CA

This project was to create a fresh identity for the Cleveland Indians Major League Baseball team to coincide with the opening of its new Baseball Park, Jacobs Field. The redesign introduced a refined baseball script based on several of the team scripts used during previous championship seasons in the 1920s, 1940s, and 1950s. The script "Indians" used on the home game uniforms needed to work for promotional items, environmental graphics, and the largest freestanding illuminated sign in the world to be built over the Jacobs Field scoreboard. The "I" from the logo is used as a secondary symbol. The program also introduced a new script "Cleveland", used for the team's traveling uniforms.

client
Cleveland Indians
design firm
Herip Design Associates
Peninsula, OH

The old Pound Interactive logo looked dated and was not relevant to its business. We created a new logo that was more approachable and modern with a hint of tech.

client
Pound Interactive
design firm
Cave Design Agency
Boca Raton, FL

Fresh Harvest Int'l

The old Fresh Harvest logo was a simple type treatment common in the produce industry. We created a logo that captures the premium quality of the produce they distribute. The icon is engaging, but understated like the personality of the company and its owner. The logo was also designed to be easily reproduced for many different applications within the produce industry.

FRESH HARVEST
INTERNATIONAL

client
Fresh Harvest
design firm
Cave Design Agency
Boca Raton, FL

The old logo was dated and did not represent the quality of the products Farmdale Creamery consistently offers their clients. We created a logo that captures the tradition and quality they offer, as well as giving the company a authentic, "big brand" feel.

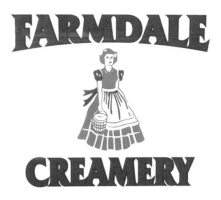

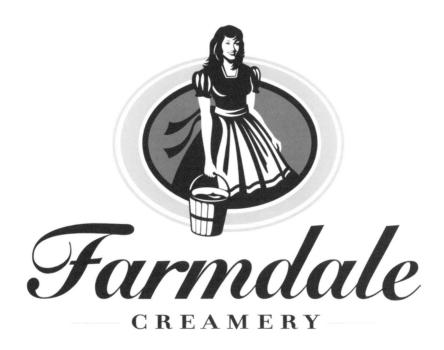

client
Farmdale Creamery
design firm
Cave Design Agency
Boca Raton, FL

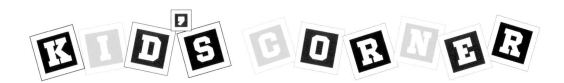

KidsWorks, part of the Hudson Group of brands, is a chain of kids' toys located only in airports.

As Hudson reviewed its brands, they felt the logo and branding looked dated and inappropriate, especially for the new, more hip and technologically-savvy customers. Silvester + Tafuro developed what they call a "logosign." Many of S+T's clients are in the retail business, where the sign is the most important use of the logo. With this in mind, the design must work well as a three-dimensional application. Two-dimensional uses, such as letterheads, are much less important for retail clients.

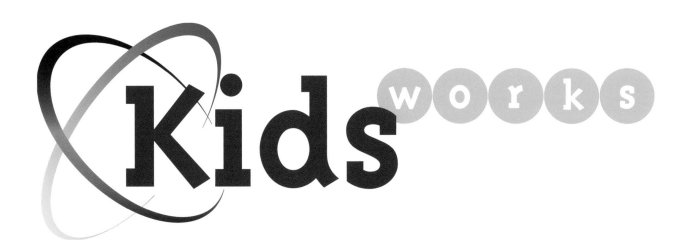

client
Kids Works
design firm
Silvester + Tafuro
South Norwalk, CT

This bank, which was only about three years old at the time, opted for a major repositioning of its image. With nondescript graphics and a nondescript building, we upgraded them to a very traditional image that emphasizes the word "COAST" while embodying strong "financial" graphic elements. Their new office is equally traditional and serves as a symbol of fiscal strength and stability, becoming a virtual "billboard" for the bank.

client
Coast National Bank
design firm
Pierre Rademaker Design
San Luis Obispo, CA

This company's software is embedded in other products and the company needed a logo that would work to convey a strong "ingredient brand," such as done by the "Intel Inside" logo. An upscale look that speaks to the product's integrity was needed, since this software helps mission-critical pieces of equipment fix themselves in real time.

client
GoAhead Software
design firm
Walsh Design
Seattle, WA

University Unitarian Church

The "cathedral" Unitarian Universalist church in the greater Seattle area, has a mission of "Shaping Leaders…Transforming Communities." The denomination's chalice and flame symbol is a common element of all UU churches and fellowships in the U.S., but UUC needed to upgrade their standard image elements to reflect its leadership standing in the community.

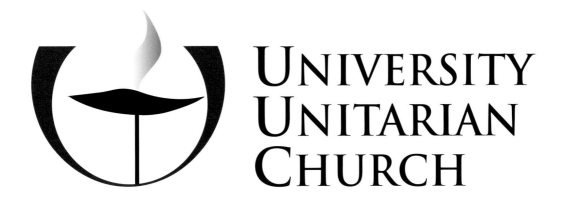

client
University Unitarian Church
design firm
Walsh Design
Seattle, WA

Hudson News

This company has been around for almost 75 years, and has grown from a small magazine and distribution company into one of the world's largest news and gift retailers with most of their 300 stores located in airports.

Hudson was emotionally attached to the old logo, which had not been changed in 25 years. This is an example of "evolutionary design" as the new logo is very much linked visually to the old one.

Hudson News

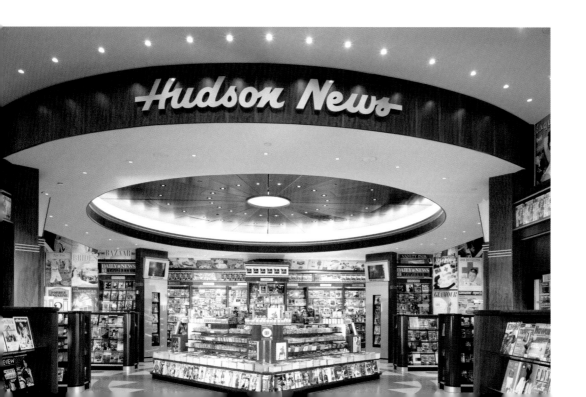

client
Hudson News
design firm
Silvester + Tafuro
South Norwalk, CT

BOLD *Enterprises*
Cultural Architects

A consultancy billing itself as "cultural architects" became a graphic challenge. Striving to depict the process of analysis and cultural dissection and redefinition, we incorporated disparate parts that "add up" to the total message. The "B" is only discovered after its defining parameters are clearly identified.

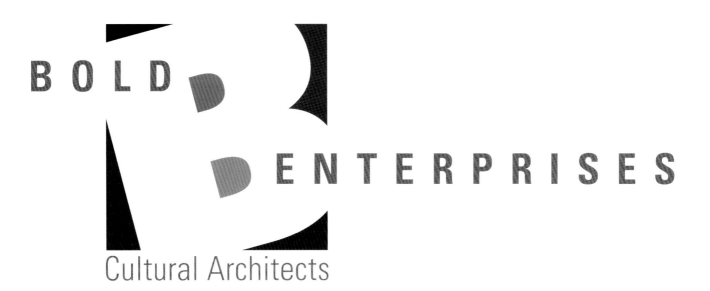

BOLD

ENTERPRISES

Cultural Architects

client
Bold Enterprises
design firm
Pierre Rademaker Design
San Luis Obispo, CA

Trendwest is an international vacation-ownership company. It needed a timeless logo that would differentiate it from the Marriotts and Disneys of the world, fit multiple vacation products, locations, and subbrands, while reflecting its brand of accommodating and delighting its customers. During the branding process, the brand message for Trendwest evolved from Trendwest selling time-share vacation property to Trendwest marketing a great vacation experience. (Even people serious about vacation quality want to have fun.) The paper airplane element in the new identity captures the feeling of something you do for the sheer fun of it, and the font treatment upgrades the classiness of the image to help Trendwest compete at a new level.

client
TrendWest
design firm
Walsh Design
Seattle, WA

The old BlueFish Concierge logo did not send the right message to its upscale audience and was hard to reproduce. Cave Design created a more graphic solution that is easy to produce in any application. The logo also has a more modern, edgy feel that captures the attitude and personality of the company.

client
BlueFish Concierge
design firm
Cave Design Agency
Boca Raton, FL

SAKSON & TAYLOR INC.

This decades-old firm's founder did not want to change the logo until research indicated that it was communicating messages such as "technology, water, and cosmetics" instead of the human elements for which this provider of quality, professional contract workers and consulting was known. Because the old graphic element communicated conflicting messages, the new logo focuses instead on the owners' names, with an ampersand connecting them to convey the mission, "We work for the thrill of the match between people and jobs, and people and information".

client
Sakson & Taylor
design firm
Walsh Design
Seattle, WA

Women Rock is a new retail concept selling edgy and unique products in airports.

The new logo clearly communicates their product line. Mostly geared towards women, they sell sexy, fun, and suggestive gifts that cannot be found anywhere else.

client
Women Rock
design firm
Silvester + Tafuro
South Norwalk, CT

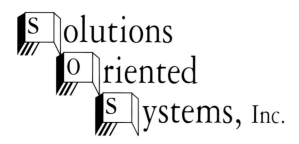

A two-pronged business (IT support and a time-and-billing software program), Solutions Oriented Systems' old identity was highly literal. The new logo highlights the "SOS." The "O" is stylized to represent the "Start" button on electronic devices. The exclamation point says "help," the power symbol represents the technical support, and the angle implies time and billing (a clock).

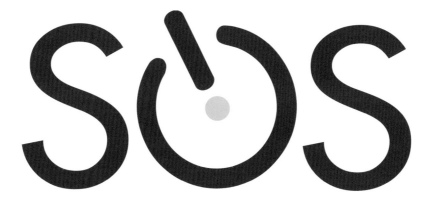

Solutions Oriented Systems, Inc.

client
Solutions Oriented Systems, Inc.
design firm
Walsh Design
Seattle, WA

A 100-year-old provider of children's services in Seattle, this organization was suffering from low employee morale, and was being confused with another local organization with a similar name. The home's work is all about transforming the lives of at-risk children and sending them out into the world, but the logo looked like a child in jail.

With the butterfly association, the new logo was designed to visually communicate the message of transformation. The logo did wonders for employee morale. It also spoke to the organization's purpose in a way that significantly boosted its fund-raising results.

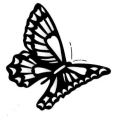

Seattle Children's *home*

client
Seattle Children's Home
design firm
Walsh Design
Seattle, WA

The primary objectives of The Cat's Meow Collector's Club identity redesign was to create a fresh servicemark for a collectors' subscription organization as a part of the unified product trademark family for The Cat's Meow Village Corporation. The design of the trademark was simplified for use in a variety of reproduction techniques including silk screening, offset lithography, and web applications. An extensive color pallet was developed along with typographic and product trademark design standards for the introduction of the new corporate program.

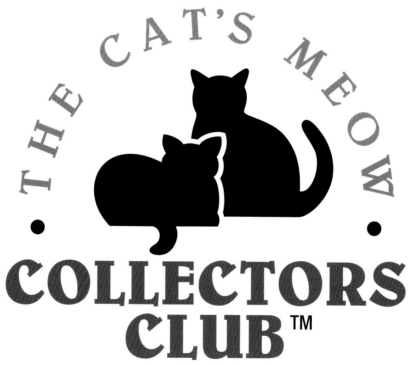

client
The Cat's Meow Collectors Club
design firm
Herip Design Associates
Peninsula, OH

eras center

ERAS, the acronym for Education, Resource, and Services needed an upgrade for their center's image which specifically deals with families with children "at risk." Children who originally start at the ERAS Center eventually end up with full and productive lives. This was an important consideration in creating the logo and is represented by the growing icons chosen to show what happens when seeds of hope are planted.

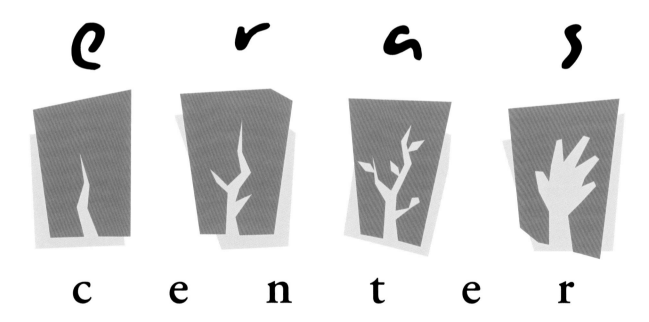

client
Eras Center
design firm
Evenson Design Group
Culver City, CA

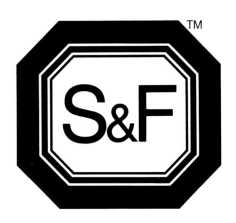

The redesign of the Stearns & Foster logo was to incorporate the integrity of the original mark developed in the early 1900s while maintaining the brand equity of the widely-recognized logo. The resulting trademark is a contemporary version of the historic mark that uses the founding date to showcase this company's history, and that is easier to reproduce in a variety of media.

client
Stearns & Foster
design firm
Herip Design Associates
Peninsula, OH

DOGGONE CRAZY!™
Family Fun Action Game

Doggone Crazy!™ is the first-ever board game to empower kids with the knowledge they need to make safe choices around dogs. Kids can be doggy detectives, trying to figure out what dogs are saying with their body language in the more than 100 photo cards. Created by dog experts, this unique game is loads of fun for kids and families. Parents and grandparents are choosing Doggone Crazy!™ for family play and educational value. Doggone Crazy!™ is for families with dogs and families who encounter other people's dogs. Even dog-savvy parents have said "I didn't know that!" after learning about subtle and little-known dog communication signals from the photo cards in the game. Kids just say "We all have fun!!".

Solution: Let's add a smilin' bone and some eyeballs just for fun!

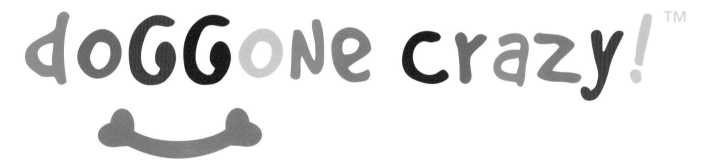

client
Doggone Crazy
design firm
Provoq Inc.
Toronto, ON, Canada

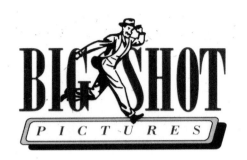

Big Shot Pictures puts together commercials, infomercials, and short films. They are a small group that needed an identity that would show their pride and stature in a field crowded with larger competitors. We decided to design around the concept of a figure shouting into a megaphone, which was used on early movie sets.

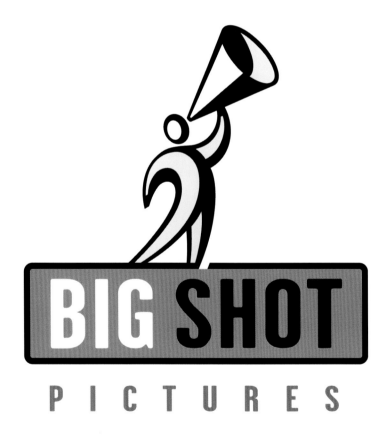

client
Big Shot Pictures
design firm
Dotzero Design
Portland, OR

The primary objective of the redesign of the Regency Mall Logo was to present a fresh new image to represent the remerchandising of the mall. The development of the new symbol preceded the announcement of the expansion and renovation of the mall. The new, contemporary Regency Mall mark was designed for use in tradeshow, print, and web promotions.

client
Regency Mall
design firm
Herip Design Associates
Peninsula, OH

Brandywine's original logo was a howling wolf that the owner had drawn. The company silkscreens and embroiders images on shirts and other articles for clients. The main use of the logo is for self-promotion specialty items and invoices. The business owner doesn't have business cards or stationery since most orders come by phone, fax or email.

The client liked two of the logos we presented so well that she decided to use them both, but for different applications. Both logos were somewhat simplified so it would be possible to embroider them.

Celtic patterns gave us the interlocking image for the initials.

The Circle logo features a "B" which is formed by what can be seen as either a needle with spiraling thread, a paint brush, or even a drop of ink above the needle to represent both the silkscreening and the stitching they do.

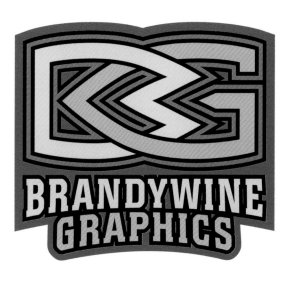

client
Brandywine Graphics
design firm
Dotzero Design
Portland, OR

University of Toronto

ENGINEERING ALUMNI
ASSOCIATION

The University of Toronto Engineering Alumni Association is the oldest and largest engineering alumni in all of Canada. Skule™ among the engineering community has been synonymous specifically with engineering within The University of Toronto for 60+ years.

Solution: Progress from the long title of The University of Toronto Engineering Alumni Association to the shortened name of Skule Alumni. Then design a logo that would communicate to the most recent graduate as well as to the 80-year-old alumnus. Have it reflect innovation and creativity, but keep it practical and focused…and for good measure, lets make it shimmer like the Iron ring.

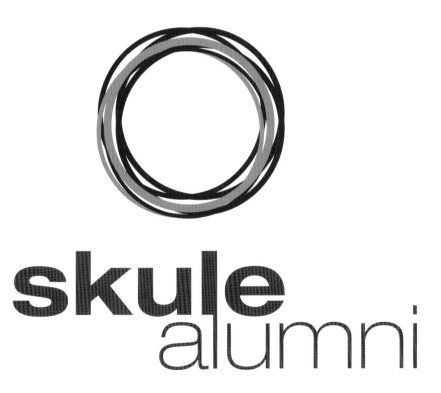

client
Skule Alumni
design firm
Provoq Inc.
Toronto, ON, Canada

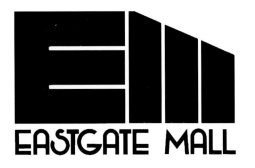

The primary objective of the redesign of the Eastgate Mall Logo was to present a fresh image to represent the remerchandising of the mall. The development of the new symbol preceded the announcement of the expansion and renovation of the mall. The new, contemporary Eastgate Mall mark was designed for use in tradeshow, print, and web promotions.

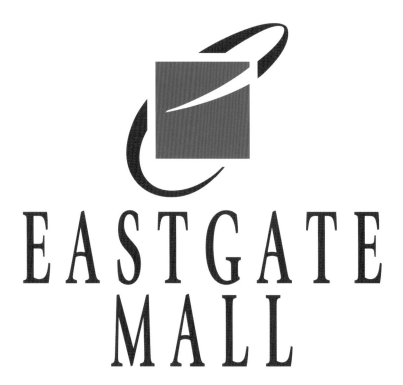

client
Eastgate Mall
design firm
Herip Design Associates
Peninsula, OH

Stutt Kitchens & Fine Cabinetry specializes in high-end architectural custom cabinetry. Styles include French Country, Rustic Mission (Shaker), Classical Georgian, and Neo-Classic.

Solution: Make sure there's no misinterpretation of 'Stutt' with 'Stuff' by keeping it clean and readable.

STUTT KITCHENS & FINE CABINETRY

client
Stutt Kitchens & Fine Cabinetry
design firm
Provoq Inc.
Toronto, ON, Canada

Zenbev™ is a delicious beverage mix of organic ingredients that provides a natural source of tryptophan. As a precursor to serotonin and melatonin, tryptophan enhances mood, emotion and sleep.

Solution: Rename the product to encompass all its benefits. Keep the design minimal, peaceful, and fresh.

zenbev

client
Zenbev
design firm
Provoq Inc.
Toronto, ON, Canada

MID-STATE BANK

A regional bank with over 40 offices, Mid-State needed to revise its logo-type when they added "trust" to their name. The stylized "M" was retained in a more refined version, and the words "Mid-State" were emphasized by presenting them in a style reminiscent of financial documents. The graphic program included all operational print materials as well as signage for each office.

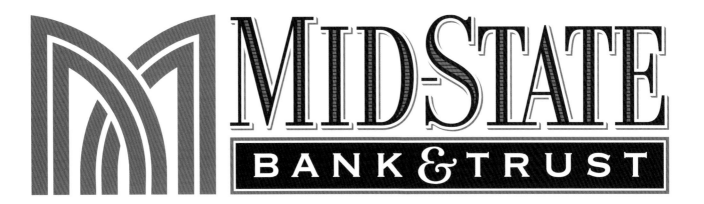

client
Mid-State Bank & Trust
design firm
Pierre Rademaker Design
San Luis Obispo, CA

The American National Bank logo needed to first simplify their eagle, which was accomplished by using just the head alone. A contemporary, graphic representation of the eagle, along with the gold star, creates a stronger, bolder look for the new symbol.

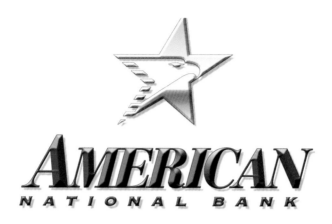

client
American National Bank
design firm
Dotzler Creative Arts
Omaha, NE

The Mall of Victor Valley logo needed updating. They wanted it to have a more current feel, but didn't want to venture too far from the original look.

The basic logo was left intact, but to add interest, we gave the type a chiseled or beveled look.

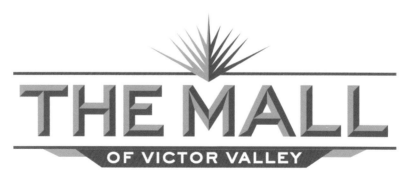

client
The Mall of Victor Valley
design firm
Dotzero Design
Portland, OR

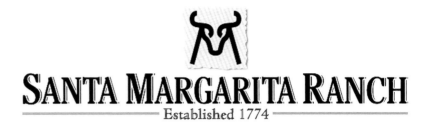

SANTA MARGARITA RANCH
Established 1774

Established as a cattle operation by California Mission San Luis Obispo de Tolosa in 1774, the ranch has operated continuously to the present day. The previous logotype relied on the brand for its identity and served the ranch well for many years. The new logotype strives to recall the Spanish-era heritage of the ranch as well as its prominent place in 19th century California history.

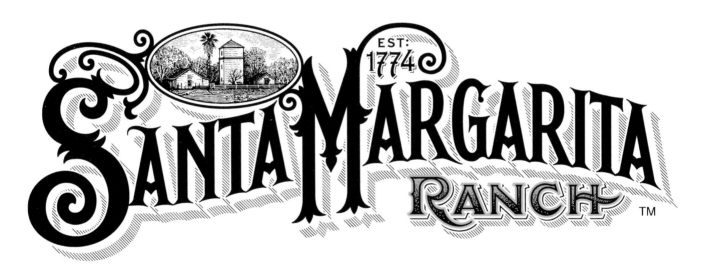

client
Santa Margarita Ranch
design firm
Pierre Rademaker Design
San Luis Obispo, CA

The foundation had a very dated logo as the design and colors were both well-worn.

Wanting to stress the fact that they are a source for information and treatment updates on psoriasis, the foundation wanted the new identity to reflect they are a community of people "there for people" who need them. They also wanted the logo cheery and hopeful, but professional. The group of figures is light and not tied down. The colors are bright and friendly. Yet the mark has a geometric symmetry that makes it very distinctive.

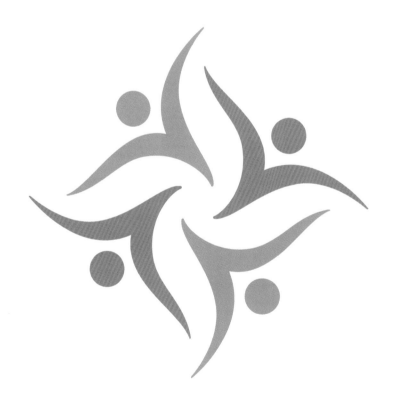

client
NPF
design firm
Dotzero Design
Portland, OR

The objective of the logo redesign was to enhance the image of the first program in the National Park System to have working farms within the boundary of a national park. The new 10-year initiative of the Cuyahoga Valley National Park is operated through the Cuyahoga Valley Countryside Conservancy. Its new logo needed to reflect the sophistication of the unique program. The new symbol was completed as part of a larger identity system for the Cuyahoga Valley National Park and four specific affiliated park partners.

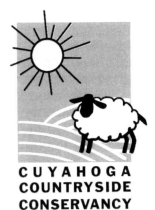

CUYAHOGA COUNTRYSIDE CONSERVANCY

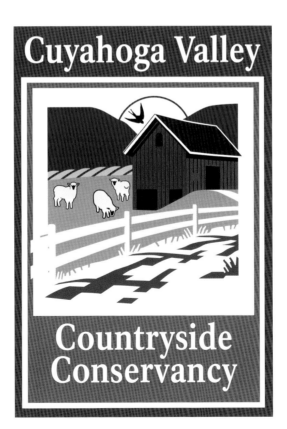

client
Cuyahoga Valley Countryside Conservancy
design firm
Herip Design Associates
Peninsula, OH

HARTFORDBUSINESSJOURNAL

GREATER HARTFORD'S BUSINESS WEEKLY WWW.HBJOURNAL.COM DECEMBER 8, 2001 VOLUME 12 NUMBER 4 $1.75

Goals of the Branding Program:

✦ Enhance the perceived quality of the *Hartford Business Journal.*

✦ Elevate the "buzz factor" of what we publish.

✦ Improve the effectiveness of *Hartford Business Journal* branding and marketing in the newspaper and through events and other external communications.

✦ Streamline and improve the reader's experience with the newspaper, its layout, content and graphics, thus enhancing reader loyalty and results for advertisers.

Old Front Page

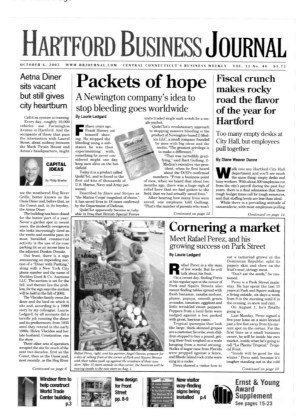

HARTFORD BUSINESS
JOURNAL

New Front Page

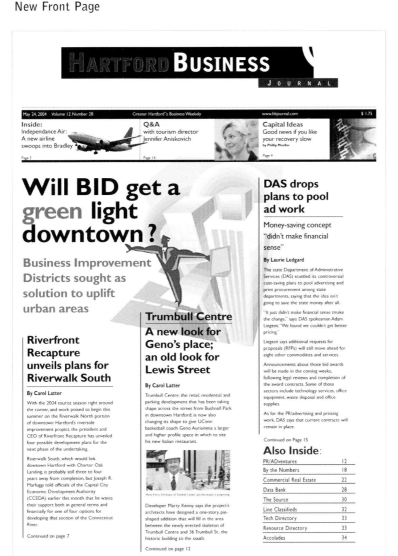

CITADEL MALL

The primary objective of the redesign of the Citadel Mall logo was to present a new image to represent the remerchandising of the mall. The development of the new symbol preceded the announcement of the expansion and renovation of the mall. The redesigned, contemporary Citadel Mall mark was created for use in tradeshow, print, and web promotions.

client
Citadel Mall
design firm
Herip Design Associates
Peninsula, OH

The objective of the redesign of the existing logo created in the 1950s was part of a marketing effort involving all new collateral material to launch the firm's 75th anniversary. The primary goals of the redesign were to present a contemporary image while maintaining the brand equity of the widely-recognized logo, and to simplify production across various print and media applications. The logo was also changed from three-colors to one-color to accommodate its expanded and more flexible use.

client
Schaefer Printing Company
design firm
Herip Design Associates
Peninsula, OH

The Stone Chair is a small gift shop in Montana. The existing logo featured a stone chair that the owner actually has at her shop. She wanted to keep the image of her chair, but the old logo was too sketchy and difficult to use for all applications of the logo. It also needed updating to look more professional.

We used a sketchy texture on the chair, but it was all bitmapped, so it would reproduce well. The dark shape anchored the chair with the type.

client
The Stone Chair
design firm
Dotzero Design
Portland, OR

A thriving tourist destination near California's Central Coast, Solvang had never developed a comprehensive graphic identity. Working with visual cliches, and inspired by the illustrative work of Howard Pyle and Carl Larsson, we created an image that strives to communicate beyond the written message, becoming a visual story that depicts the mood of the place.

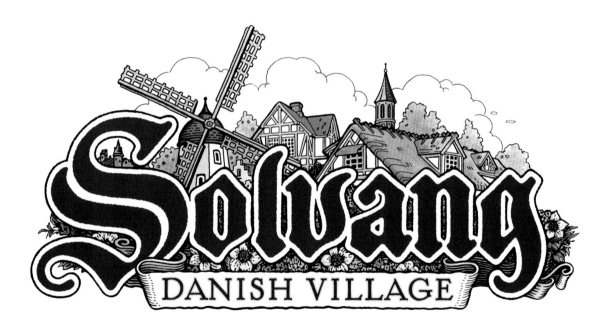

client
Slovang Danish Village
design firm
Pierre Rademaker Design
San Luis Obispo, CA

Mother's is a very nostalgic, old-fashioned tavern in the heart of San Luis Obispo's historic downtown. The previous logo, although charming in some ways, lacked the obvious historicism that we felt would be more appropriate. The final identity is part of an overall upgrade of the building facade, signage, and interior that resulted in a comprehensive image enhancement for a well-established business.

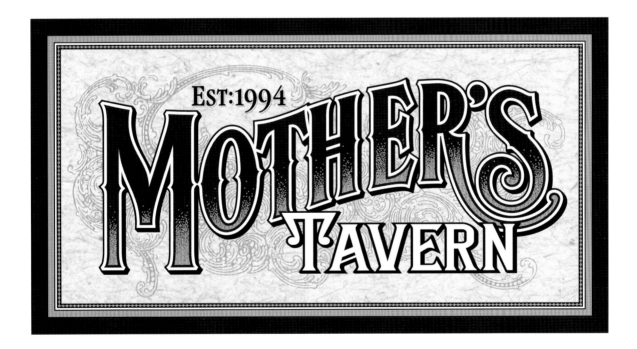

client
Mother's Tavern
design firm
Pierre Rademaker Design
San Luis Obispo, CA

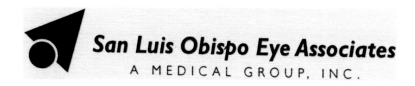

Creating an identity that balances professionalism with playfulness was a challenge when working with this local group of eye surgeons. After numerous "focus" trials, we settled for a level of blur that retains the legibility of the word "Eye" but still provides a stark contrast to the clear focus depicted inside the lens. The result clearly communicates the emphasis of the medical practice.

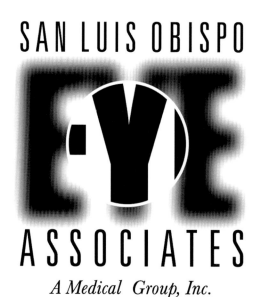

client
San Luis Obispo Eye Associates
design firm
Pierre Rademaker Design
San Luis Obispo, CA

Having been a family-run company since 1930, Tait Engineering has seen many changes and has greatly evolved into a well-rounded, experienced company. Their original logo, created by owner Don Tait, showed exactly what they do—land surveying and civil engineering. With the company preparing to change hands to two of Don's sons, the company's outlook has changed. With this, the corporate identity needed to change as well.

The new identity had to create more than just an image. It had to visually portray the company and all that it represents. The two parts of the 'T' represent the two brothers coming together as one; they are the future of this company. The shadow symbolizes the depth and years of experience behind the company. Together, the formation of the "T" and the shadow show what the company is about—two brothers coming together to not only successfully run the company, but to carry out the tradition.

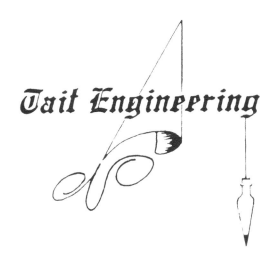

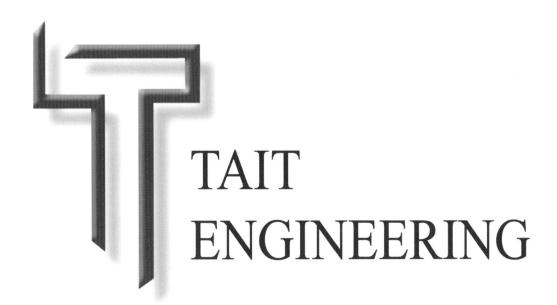

client
Tait Engineering
design firm
Erisa Creative, LLC
Pittsburgh, PA

Unicru helps its clients find and screen applicants for job positions through interactive kiosks and surveys given to prospective employees. With this process, Unicru is able to narrow the field of applicants to the kind of worker a client is seeking.

At first, Unicru was a company helping clients find hourly employees. We actually designed the first logo, which became obsolete when Unicru expanded into the area of salaried workers.

The client liked the typeface and colors of the original logo, so an "evolutionary" logo was created. The crowd of people in the new logo suggests the pool of applicants, with the one singled out as the segment of the pool that Unicru has targeted as good candidates.

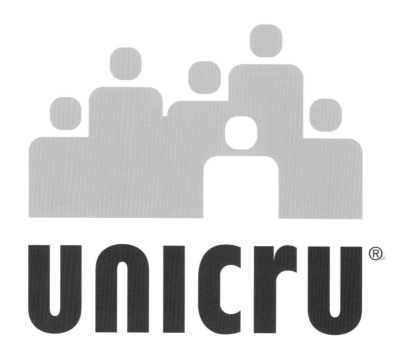

client
UNICRU
design firm
Dotzero Design
Portland, OR

Trinity Church's logo symbolizes God's Living Word (Bible) with a dove (Holy Spirit) together in the shape of a triangle (Holy Trinity). The church wanted to revise it with a fluid, watery look that symbolizes the satisfying water (river of life) given only by Jesus.

TRINITY CHURCH
INTERDENOMINATIONAL

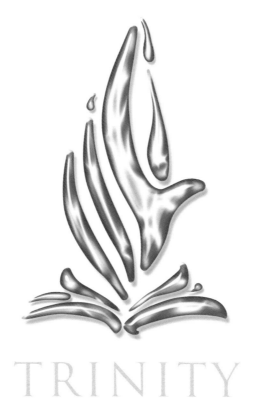

client
Trinity Church
design firm
Dotzler Creative Arts
Omaha, NE

SONITEK

Sonic Corp. is engaged in the manufacture and sales of sonic and thermal technologies. Their old logo was plain, ordinary, and communicated very little about the company.

The objectives of the new logo were to graphically depict a company on the move, and to show the company as a leader in its field. This is accomplished with the use of bold and underscored type for the company name. The color red used in the circle of thermal waves signifies heat generated by the various applied sonic and thermal technologies, thus visually communicating something about the company. The new logo is distinctive, bolder, and much more representative of the company. It also more clearly supports the company's mission statement and objectives.

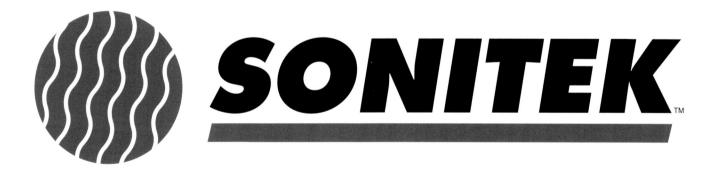

client
Sonitek
design firm
Kevin Hall Design
Milford, CT

RAM digital ⋮.

RAM Digital came to us for a fresh approach. The company's previous logo was designed quickly, in-house, and they were never quite satisfied with it as a trademark. "We were allowed free reign to play with any concepts, visuals, and colors. This was rebuilding from the ground up," said Sue Hough, art director on the project. RAM Digital develops traditional multimedia and innovative web applications so they needed to look like a new media company. The icon shows an interlocking shape growing, while encircling a perfectly formed shape to reference technology/multimedia growing beyond conventions to create a perfect solution. The typeface Preface was used for its clarity and boldness.

RAMDigital

client
RAM Digital
design firm
Octavo Designs
Frederick, MD

Cairns + Associates' practice consists of refining, promoting, and maintaining its clients' brands, products, and identities. Cairns' own identity materials need to demonstrate competence and creativity, but at the same time be understated enough so they won't compete with their clients' brand elements.

The original logo was a rectangle enclosing a photo of clouds, with the characters C, A, and ampersand imposed on the photo, cropped at the border. The Goudy typeface gives the letters a graceful feeling, and the clouds are meant to represent creativity or thinking. However, clouds can also "block the sun" (as Joni Mitchell observed in the song *Both Sides Now*), and enclosing them within a border could connote thinking "inside the box," or, worse, "cloudy thinking." The clouds image also makes the logo very difficult to reproduce, driving up the cost of company materials. The letter C, which represents the name of the company owner, is heavily cropped and difficult to recognize.

The new identity is simple, elegant, and open. It includes company signature, company symbol, and a design principle to encourage creativity in identity materials.

CAIRNS + ASSOCIATES

client
Cairns + Associates
design firm
Ethan Ries Design
Brooklyn, NY

Tom Fowler, Inc. was selected by the Maritime Aquarium at Norwalk to design their new logo. Their original name, The Maritime Center at Norwalk, no longer reflected the direction in which they were moving. The addition of an aquarium and other live sea life exhibitions to the original boat building focus required a name change and a new look. We developed a seal icon as an instant identification for live sea life. The mix of traditional and contemporary fonts brings the sense of old and new to the logo. The bubbles rising from both the typography and the seal add a playful element to the logo, capturing the feeling of the facility.

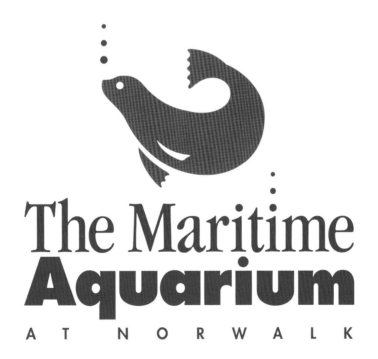

client
The Maritime Aquarium at Norwalk
design firm
Tom Fowler Inc.
Norwalk, CT

Denver Tech Labs, a high-tech digital security company, changed their name to Enspherics to appeal to a broader-based corporate clientele. EDG was asked to provide a contemporary logo that reflected "the new science of security" tagline as well as their new mission statement.

EN**S**PHERICS

client
Enspherics
design firm
Evenson Design Group
Culver City, CA

The client, Vodovod-Kanalizacija Ljubljana, is the town water supplier. Their corporate identity was created in a time when, after World War II, all town companies were required to have a dragon in their corporate identity because a dragon on the castle tower is a symbol of the town of Ljubljana.

In the past, Vodovod-Kanalizacija Ljubljana didn't have their own company building, but with the completion of a new office building, there was an opportunity to design a symbol which would be more appropriate to the service they offer.

A stylized "V" in blue with waves symbolizing water complete the dynamic as a shape of a lost water dragon.

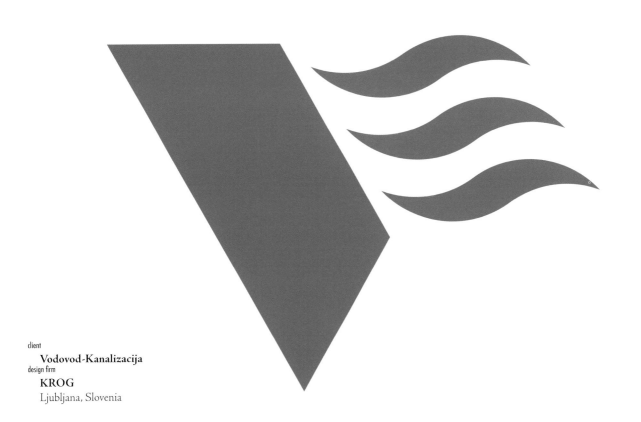

client
Vodovod-Kanalizacija
design firm
KROG
Ljubljana, Slovenia

KEVIN HALL DESIGN
Strategic Design and Marketing

My business is graphic design and one of my firm's strengths is logo and trademark development. While evaluating the effectiveness of my firm's old logo, I came to the realization that if I was to encourage clients to consider upgrading their own business identities, then my own business identity needed to be upgraded as well. The logo which previously represented my firm appeared plain and ordinary without looking very creative or unique.

The new logo representing Kevin Hall Design is more distinctive, bolder, unique, and memorable.

Kevin Hall Design

client
Kevin Hall Design
design firm
Kevin Hall Design
Milford, CT

The Faculty of Law at the University of Ljubljana, Slovenia, had been moved to a new location and become aware that a new symbol and identity was needed. They didn't want to be just another part of a visual channel among 26 other faculties at the university, but wanted to have personally-designed visual elements.

It was decided the design should reflect distinction and calmness.

A balanced set of scales is an old symbol for the law and court system. Truth is in dynamic balance between two sides. To use this symbolism in an updated way, I chose to incorporte the intial letters into a simplified "balance." The middle part of the logo "f" is the tong between the balance of "P" (pravo=law) and "I" (iuridica=law). Blue Pantone 293 was chosen to represent wisdom.

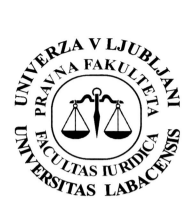

Pravna*fakulteta* *facultas*Iuridica

client

Pravna fakulteta
(The Faculty of Law,
University of Ljubljana)

design firm

KROG
Ljubljana, Slovenia

MOD Events is an event planning firm located in eastern Long Island, serving a high-end clientele. The company handles all kinds of events and celebrations with a special interest in off-beat approaches and treatments.

The original logo does have a certain wackiness, but we thought it looked almost like a heavy equipment manufacturer, or even a company making climbing gear. The simple letter shapes suggest strength, but without the artistic bent that's unique to the company. The backwards "D" was an attempt to make the logo read both ways, in a reference to "Dominique," the founder. We thought that was too obscure for anyone but friends and family.

The "O" of MOD has been turned into a simple circle. Having this shape in the middle of the logo keeps it centered and strong. On the left, the letter "M" has a conservative feel, which suggests the company can handle traditional events like weddings in an elegant way. On the right is a hand drawn "D" which creates an artistic feeling with a little irreverent humor. We added bright colors to increase the mark's energy and impact.

client
MOD Events
design firm
Ethan Ries Design
Brooklyn, NY

Enforme Interactive brought us in for a total redesign of their logo. They wanted to move away from an emphasis being placed on the "e" of their name, to devise a trademark that complemented their new tagline, "Giving Form To Electronic Information." We moved the emphasis to the center of the logo for visual balance and created a spiral wave shape which alludes to "giving form." The introduction of the vivid green updates their color palette to a shade more modern. This redesign became the basis of a complete corporate identity overhaul for their print materials and website.

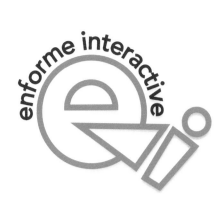

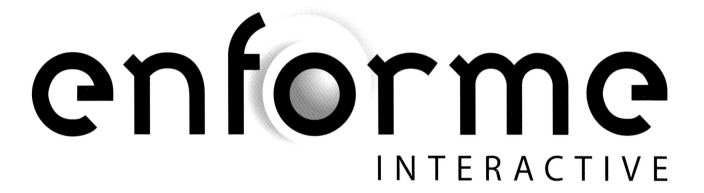

client
Enforme Interactive
design firm
Octavo Designs
Frederick, MD

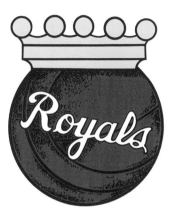

Grace University needed a logo for their new Royals sports facility. The "king of the beasts" lion head and crown, representing royalty, along with an athletic three-D font helps give this logo a strong, sporty look. The logo is also used on several clothing items in the university's store.

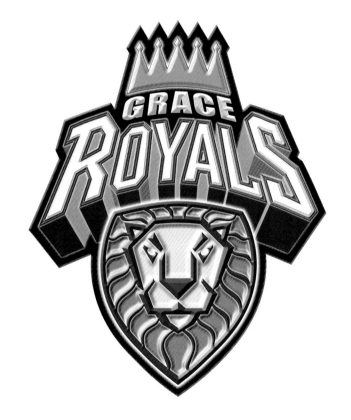

client
Grace University
design firm
Dotzler Creative Arts
Omaha, NE

This point-of-purchase manufacturing client needed a new identity program for their very tired 1970s image.

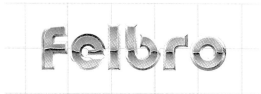

FELBRO

client
Felbro
design firm
Evenson Design Group
Culver City, CA

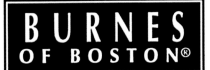

Newell/Rubbermaid's picture frame businesses were known only by their disparate brands, not as an integrated whole. The *objective* was to reposition the division with a unifying new corporate identity—"Burnes Group". The notion of a frame, abstracted and reduced to its simplest form, provided the inspiration and the drive for a fresh, innovative identity system. The spare, simple, clean identity captures the unit's new spirit and expresses it visually. The logo interacts with its environment. Like a frame that enhances its subject, the new Burnes mark participates in its applications while conveying the new brand's meaning. *Result:* The new identity, together with other factors, paved the way for the recent acquisition of the division by Cerberus.

burnesgroup

client
Burnes Group
design firm
Source/Inc.
Chicago, IL

With an old mark that was under-performing in the marketplace, and also failing to depict a hot, exciting team on the rise, the NBA called on us to create a new 76ers identity. They wanted a design that made use of the elements in the old logo in a much more modern and exciting way. Aided by the wonderful guidance of Tom O'Grady, the creative director at NBA Properties at the time, we supplied numerous concepts playing with the rich, patriotic theme. The chosen design combines the original logo's basketball, stars, and "76ers" wordmark with a dynamic sense of motion and excitement.

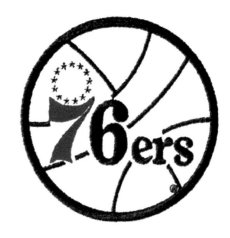

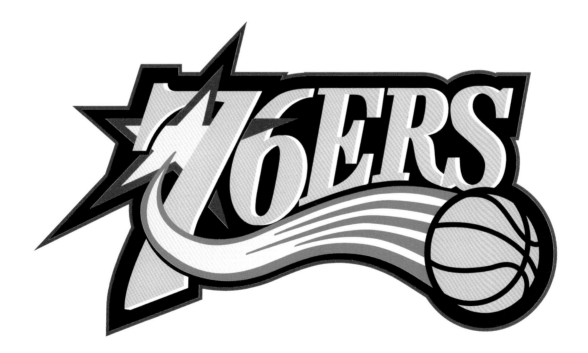

client
Philadelphia 76ers
design firm
Rickabaugh Graphics
Gahanna, OH

VSA Educational Services

Educational Services, Inc., is a government consulting firm dedicated to improving education, health, child welfare, and family services across the United States. The original logo, created 15 years ago, reflected the firm's narrower focus of integrating disabled individuals into the broader community. Given that a circle comprised of smaller circular entities can represent family issues, communities, and the bringing together of many parts to create a whole, it was decided to keep the mark intact and to modernize the typography and graphic approach (similar to FedEx's brand update from Federal Express.) Also, the name of the firm was shortened to its acronym, since most clients and employees referred to it in this manner.

integrity
creativity
flexibility
accountability
resourcefulness
excellence

Educational Services, Inc. • www.esi.dc.com
1150 Connecticut Avenue, NW, Suite 1100, Washington, DC 20036 • telephone 202.628.8080 • facsimile 202.628.3812
7235 Old Georgetown Road, Suite 400, Bethesda, MD 20814 • telephone 240.744.7000 • facsimile 240.744.7005

client
Educational Services, Inc.
design firm
Beth Singer Design
Arlington, VA

The MacNeill Group, a 58-year old insurance company, had gone through several buy-outs and name changes before the senior management purchased the company and renamed it back to its origins. During the last buy-out process, the management quickly designed a logo they could use to get the company into order.

The strong "M" that was so pronounced in the old logo was recognizable, but the stylization had to be refined or upgraded to something more advanced. In the new logo we improved the "M" to be more friendly and youthful which are traits of each manager and employee with the firm. In addition, our metaphor of their company being a bridge, is transcribed in the new logo. The use of lowercase letterforms in the name, as well as it being typeset with no spaces, shows a company with vision, insight, and willing to take risks.

macneill group

A MEMBER OF focus HOLDINGS

client
MacNeill Group
design firm
Gouthier Design
Fort Lauderdale, FL

South Jersey Industries

South Jersey Industries is an energy services holding company in Southern New Jersey. After acquiring additional energy services, SJI needed to update their old identity to equally represent all three of their main services. The new logo is a three-tiered flame encapsulated in a sphere. Each flame represents one of the companies main divisions: gas, electric, and resource management. Some of the attributes of the old logo were carried over to the new logo; the interlocking SJI initials are now the interlocking flames. The old logo was too dark and ominous, and presented the wrong public image. The new logo is all about energy. It needed to be bright and vibrant, but we retained a blue color associated with natural gas. The previous logo's static rounded-corner, square shape needed to be more organic. An oval was a perfect solution to contain the harmonious flames.

South Jersey Industries

Where we put all of our energy™

client
South Jersey Industries
design firm
The Star Group
Cherry Hill, NJ

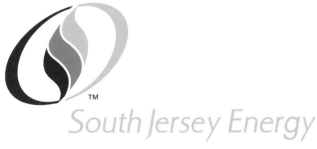

South Jersey Energy

Where we put all of our energy™

South Jersey Gas

Where we put all of our energy™

Evenson Design Group gave a fresh look to this Los Angeles-based, private training gym.

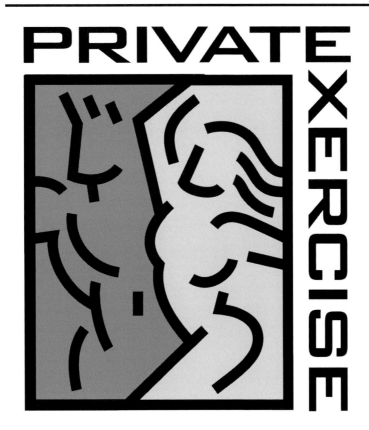

client
Private Exercise
design firm
Evenson Design Group
Culver City, CA

Withers/Armstrong

Marketing / Advertsing / Public Relations

This project involved creating a new image for a marketing/advertising/ PR firm in order to communicate a contemporary look and feel. The use of a dimensional look with shadows illustrates their creative abilities, as well as their strengths and knowledge of branding and positioning for their clients. To compete with other agencies who are more well-known, their image must convey that they are competent, have a strong foundation, and are contemporary thinkers.

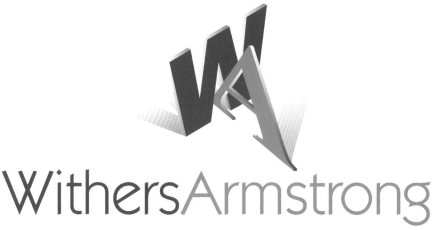

client
Withers Armstrong
design firm
Sullivan Marketing
Phoenix, AZ

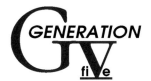

The new logo is a very unique way of showing Generation Five, without a typical "G" and "5" monogram. The logo works with and without the company name, and is unexpected in its successful solution that sparks the question "what is g five?" The new logo uses the principles of Gestalt in the incorporation of the number 5 into the spelling of five. The reader sees "five" versus what is really there "5ive." Navy blue conveys stability, comfort, and professionalism while metallic gold conveys money. All caps were used to convey a stable, conservative company that is trustworthy.

G | 5IVE

GENERATION FIVE MORTGAGE

client
Generation Five Mortgage
design firm
Catalyst Creative, Inc.
Denver, CO

The Philadelphia College of Textiles & Science needed to rebrand the school with a new name and image. After successfully changing their name to the University of Pennsylvania we realized their sports team division identity was also in need of an update. The old logo was hand drawn and not very representative of a sports team. The new logo had to be modern, aggressive, and, most of all, feel like a sports identity. We utilized their new school colors along with a pointed serif italic type to give it a feeling of motion. Swooping lines and a charging Ram's head not only increased player and team confidence, it also increased t-shirt and hat sales tremendously.

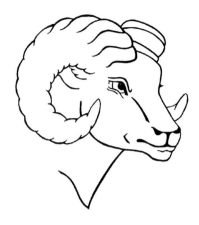

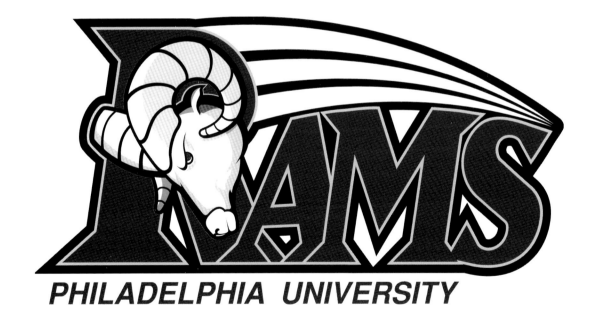

client
Philadelphia University—Rams
design firm
The Star Group
Cherry Hill, NJ

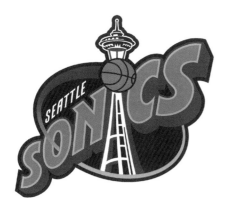

The Seattle SuperSonics NBA basketball team was feeling the backlash of a series of season disappointments, including decreased ticket sales and reduced interest by the fans. The team's new owners wanted to create an overall identity redesign meant to reflect a timeless look in order to generate more excitement for the team among the fans and players.

When the team debuted in 1967 - 68, it had no history, so it borrowed the Space Needle, the city's most famous landmark, to provide an identity. The most important goal of the redesign was to get back to the game of basketball. Hornall Anderson partnered with the Sonics' organization to create a timeless look, composed of the classic attributes shared by logos of such teams as the Cubs, Packers, and Yankees. The strength and honesty behind the Sonics symbol renders these ideals tangible.

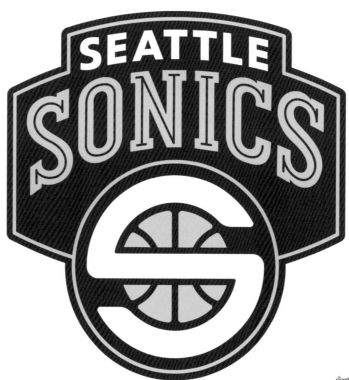

client
Seattle Sonics
design firm
Hornall Anderson Design Works
Seattle, WA

Screamer Hats is a local Seattle company that creates innovative winter hats and neck warmers. The fish is a piranha, a screamer fish—wild and energetic. This fish had brand equity, but the design was too complex. Hornall Anderson was asked to evolve the identity to continue to resonate with the young energetic audience, but to also create a friendlier look and feel that would appeal to all audiences.

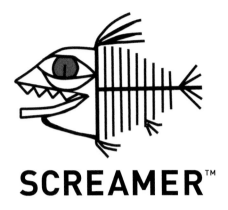

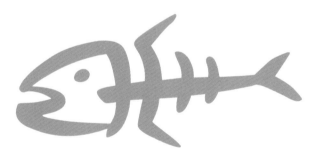

client
Screamer Hats
design firm
Hornall Anderson Design Works
Seattle, WA

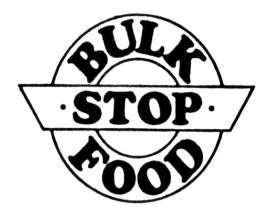

Bulk Food Stop is a bulk food retailer with two locations.

The new logo reflects the recommended name change to simply "Bulk Stop." A modern, graphic "B" icon was developed as the core of the logo. This icon is used in the stores wherever possible to reinforce the new brand identity.

Editor's Note: For anyone who asks "how can a logo change a company's image?" this is Exhibit A. The old design is so plain that it has little meaning. The new design is powerful and makes a great first impression.

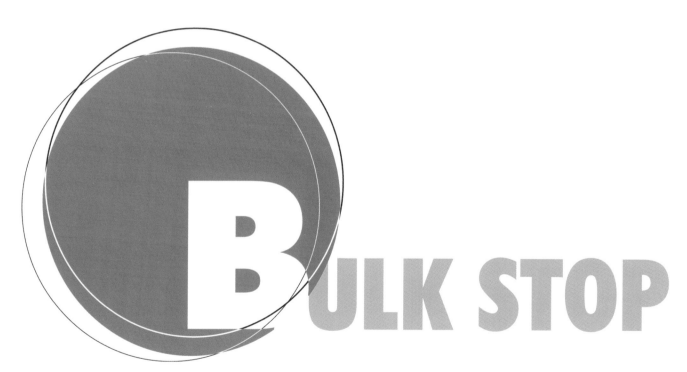

client
Bulk Stop
design firm
B2 Communications
Whitby, ON, Canada

The Riveredge Resort needed an updated identity which would better represent it as an upscale four-star resort on the water in the 1000 Islands.

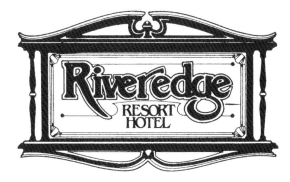

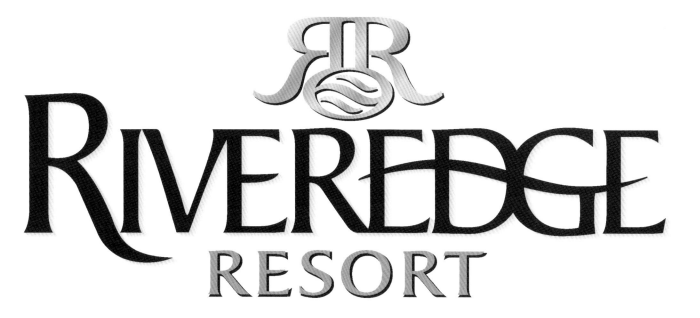

client
The Riveredge Resort
design firm
McElveney & Palozzi
Rochester, NY

![BATTLESHIP logo banner]

The new wave of patriotism in our country inspired Hasbro Toys to look at revitalizing the identity for the popular Battleship game. The old logotype was very legible but evoked little of the excitement contained in a game that has provided countless hours of fun over many decades. We decided to allow the letters of the name "Battleship" to form the hull of a very imposing ship bearing down on the viewer. With guns aimed and ready to fire, the new logo is certain to demand attention on a shelf.

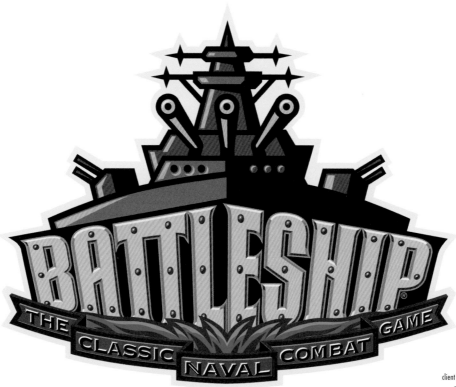

client
Hasbro Toys
design firm
Rickabaugh Graphics
Gahanna, OH

This 24-year old, private K-through-8th school needed an upgrade for their image. The simple schoolhouse visual was replaced with a more active logo showing children.

Westchester
Neighborhood School

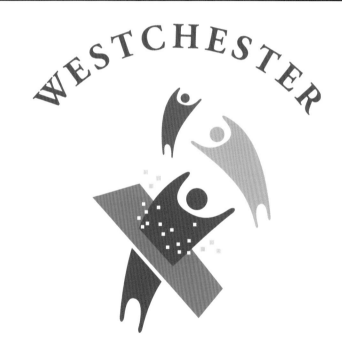

WESTCHESTER

NEIGHBORHOOD
SCHOOL

client
Westchester Neighborhood School
design firm
Evenson Design Group
Culver City, CA

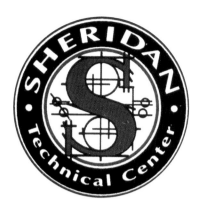

The old Sheridan Technical Center logo brought to mind something that has a long history, as well as being similar to logos of many institutions that market to continuing education students and those who are looking to advance their careers. We first looked at the curriculum and found they offered everything from culinary arts to auto-mechanical training. How does one fit that into a logo? We thought we would address the issues of importance from the old logo as the new logo should not only relate to the fields of study, but should not be a major leap for those already attending the school, either. We kept the circular formation and stylized the "S" so that it was more technical looking, thus relating to the industrial side of the school. The color selection of the bright green and gray blue again was to highlight that there were new and fresh ideas happening on the campus.

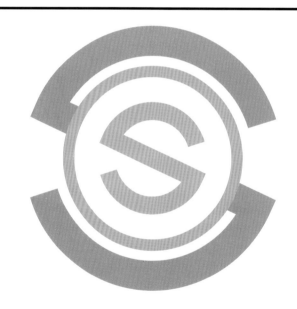

SHERIDAN
TECHNICAL CENTER

client
**Sheridan
Technical Center**
design firm
Gouthier Design
Fort Lauderdale, FL

The original Space Needle was completed for the grand opening of Seattle's 1962 World's Fair structure. The identity served as a visual interpretation of the structure. One of the most challenging aspects of the Space Needle was maintaining the integrity of the original structure, at the same time insuring that the visitor experiences created and enhanced by the new designs were current and relevant to today's audiences. The greatly simplified design still represents the Space Needle quite well, but its proportions are much easier to work with, and the image is a step forward from a 1960s design style.

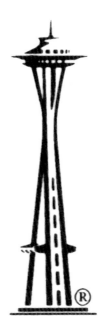

client
Space Needle
design firm
Hornall Anderson Design Works
Seattle, WA

Prufrock's is a very popular coffee house on the college campus of the University of Colorado in Boulder, but you would never know it by the old logo. It did not convey anything about what Prufrock's does. It is so generic it could easily have been used for practically any company. The owner knew it was time for a change when one Sunday morning, some pedestrians wandered in by accident and told him they had "no idea that this was a coffee house from the sign outside." Big problem.

The new logo conveys "coffee" loud and clear. The solution uses a coffee stain ring for the "o" in the name. The description "coffee & more" was added to leave no question as to what Prufrock's does. The colors were changed from blue and grey to two different representative shades of coffee brown. The owner wanted to keep the typeface used in the old logo, but it no longer bounces up and down on the baseline. The new logo successfully communicates exactly what Prufrock's does. Now everyone knows Prufrock's is a coffee house.

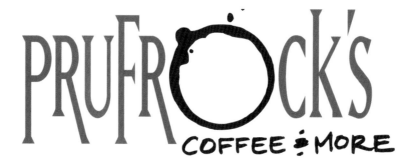

client
Prufrock's Coffee
design firm
Catalyst Creative, Inc.
Denver, CO

NetBank® is the country's largest independent retail Internet bank, providing banking and mortgage lending through a number of wholly-owned subsidiaries. The key question was whether NetBank should have a family of brands or if the NetBank brand would be strong enough to encompass the other components of the financial institution.

Research proved that although the NetBank brand was focused on the primary internet banking services channel, its equity was strong enough to serve as the corporate brand and encompass the remaining components. From this in-depth evaluation, Addison Whitney recommended that NetBank remain the master brand and distinguish each channel utilizing descriptors.

Addison Whitney created the new corporate logo, allowing for the integration of each channel descriptor by presenting it underneath NetBank in the visual treatment. This provides an intuitive visual hierarchy and allows for optimal flexibility in the acquisition or creation of new channels.

NetBank

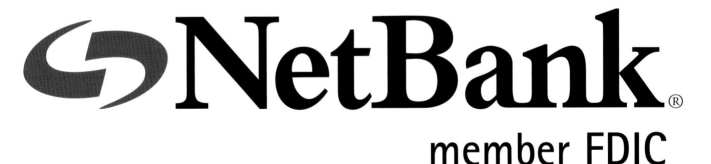

client
Net Bank
design firm
Addison Whitney
Charlotte, NC

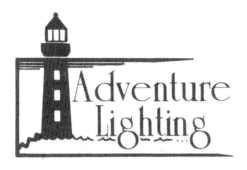

When a Des Moines lighting company changed locations, the owner took advantage of the opportunity to ask local graphic designer John Sayles to develop a new visual identity. Sayles' original illustrations in a dynamic new logo gave Adventure Lighting a strong updated image.

The company's existing letterhead had been designed by a member of Adventure Lighting's staff. Printed in mauve and grey, the old stationery featured a clip-art version of a lighthouse. In Sayles' updated, custom version, the company name is hand-rendered in a type style that complements the main graphic. Yellow "beams of light" and a sans serif letter "A" surround a lighthouse. "The lighthouse icon was an image of significance to the owner, and we wanted to use it in the new letterhead," says Sayles. "I updated the lighthouse, selected appropriate colors, and developed a layout with more striking visuals."

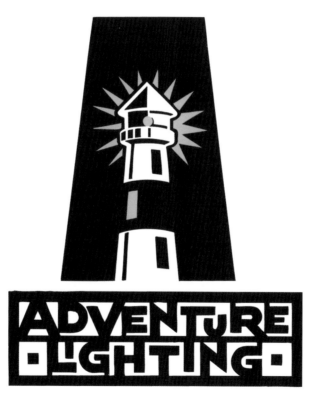

client
Adventure Lighting
design firm
Sayles Graphic Design
Des Moines, IA

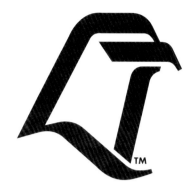

The old logo for Bowling Green State University athletics had been in place since 1970. Though its stylized design makes it hard to decipher as a falcon, it had become ingrained in the tradition at BGSU. For this reason, when Bowling Green asked us to create a new, revitalized retail mark for athletics, we knew that we couldn't stray far from the original. We maintained the old logo's outline, kept its simple linework, and added a forward moving wordmark. The result is a new exciting mark, undeniably a falcon, yet very much in touch with the BGSU past.

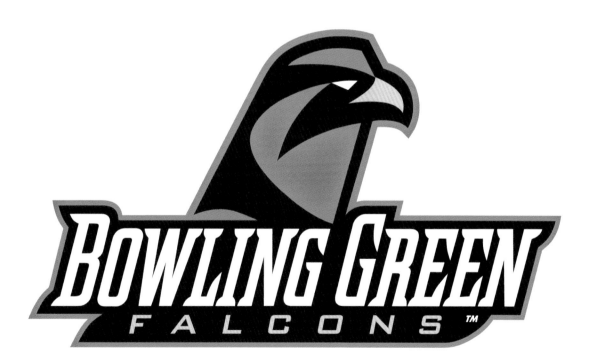

client
 Bowling Green State University
design firm
 Rickabaugh Graphics
 Gahanna, OH

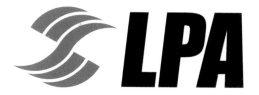

Formerly LPA, this strong, bold graphic in combination with distinct type communicates the innovative product and service offering that enables XELUS to compete and dominate in its' market place.

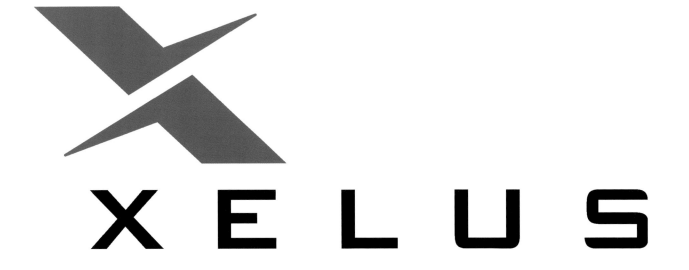

client
XELUS
design firm
McElveney & Palozzi
Rochester, NY

Public Affairs Management provides government relations and lobbying services to regulated businesses. Their logo was too old fashioned for a company with the latest knowledge of governmental regulations. The new mark had to have a more distinguished image, but also needed to retain the capital dome icon for brand transference. The previous logo color did not support the company image, so a bold red and deep blue palette were chosen to correspond to the American governmental image. The star is symbolism for the client inside the capital dome. This conveys that Public Affairs Management will get you in the government agenda.

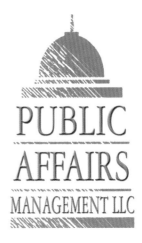

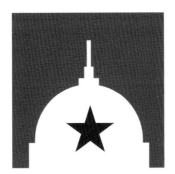

PUBLIC AFFAIRS
MANAGEMENT

client
Public Affairs Management
design firm
The Star Group
Cherry Hill, NJ

Tlx Inc.

Transportation Logistics Management

TLX, Inc. provides web-based, outsourced services that manage and process layover hotel rooms and related requirements for crewmembers in the airline and other travel-related industries. Striving to provide clients with the most reliable and cost-effective solutions by continually meeting and exceeding their expectations, it was necessary their new image reflect the future and have worldwide appeal. Because the logo would be used in a co-op manner, the simpler the look, the easier it would be to reproduce. At the same time, the image had to communicate TLX's identity and not be overpowered visually.

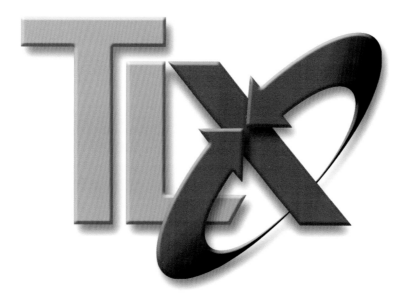

client
TLX
design firm
Sullivan Marketing
Phoenix, AZ

THE SHAW CENTER
FOR AESTHETIC ENHANCEMENT, Ltd.

The new logo would replace the client's simple, typographical solution and upgrade to a more dynamic, visually-exciting design that would attract an upscale clientele. It must also show credibility and expertise, reflecting training and experience, because this is the most important qualification in selecting a plastic surgeon.

The image had to reflect the contemporary design and image of the office interior.

Dividing the "S" shape communicates that there are other disciplines offered at the center such as skin care treatments, etc. Located in north Scottsdale, AZ, the image had to compete with the other surgeons in that area.

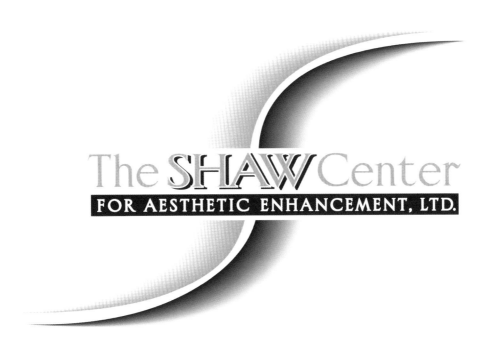

client
The Shaw Center
design firm
Sullivan Marketing
Phoenix, AZ

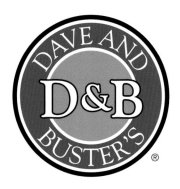

When your business is providing a fun place to gather for great food and exciting video games, your logo had better match that same sense of fun. This was not the case with the existing Dave & Buster's logo. It not only portrayed a static image, but also emphasized the initials "D&B" rather than the establishment's full name (a particular problem since another famous "D&B" business already exists...Dean & Barry Paint). Relying on just a playful treatment of letters, the new logo evokes a feeling of the fun that waits through the doors of your local Dave & Buster's.

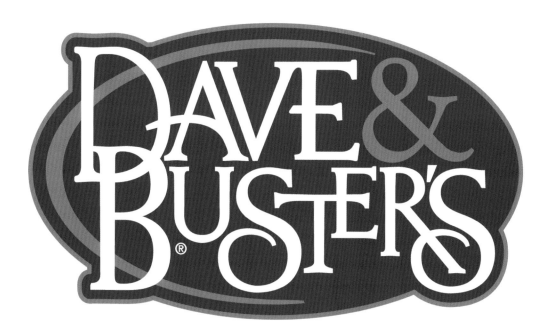

client
Dave & Buster's
design firm
Rickabaugh Graphics
Gahanna, OH

The aim of this design was to create a classic, strong, and identifiable logotype to the Miss America Organization, as well as to update their look which had been consistent for a very long time. The crown was a mandate in the final solution. Use of red, white, and blue were also requirements in developing the look and feel. On the corporate stationery, the crown is blind embossed and the logotype made the first impression. Modifying Palatino typeface and placing of the stars help position the upscale look they we were trying to achieve.

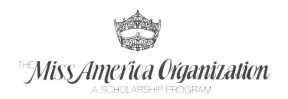

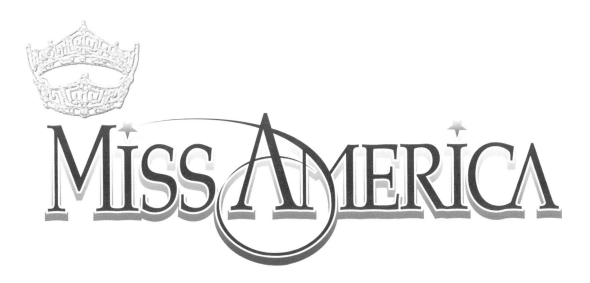

client
Miss America Corporation
design firm
Sullivan Marketing
Phoenix, AZ

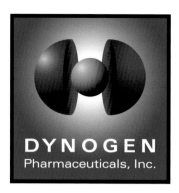

Dynogen Pharmaceuticals is a neuroscience-based drug development company targeting first-in-class and best-in-class therapies for genitourinary (GU) and gastrointestinal (GI) disorders. The company uses a neurology-based approach to treating these disorders, by interrupting the signals from the brain to the bladder and colon.

The old logo was difficult to reproduce and difficult to read. We were not even sure what it represented.

The new logo makes reference to the signals from brain to body that is the hallmark of their discovery approach. It focuses clearly on the word DYNOGEN, eliminating the word "pharmaceuticals" as an intentional focus in branding the name. The font is custom-drawn for the company.

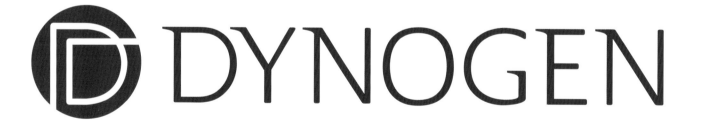

client
Dynogen Pharmaceuticals, Inc.
design firm
Fassino Design
Waltham, MA

The original Dub House logo, as a concept was very strong, but the execution felt very bulky. The stretching of typographic forms in the original hindered a viewer's reaction to the company at the forefront of reproduction technology.

Our new solution looked at the CD, DVD, and Video industry, and the products and the circular form came to the surface in each arena. The refinement of the letterform, along with its pairing of a more technical-looking font, solidifies the pairing of the company and its technology.

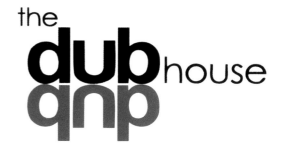

client
The Dub House
design firm
Gouthier Design, Inc.
Fort Lauderdale, FL

The Olive Garden desired a warmer, more welcoming feel to complement its popular "Hospitaliano" restaurant concept.

Consumer research revealed that the Olive Garden's corporate identity, a typeface featuring neon green lettering on a green background, projected an outdated feel. To overcome these challenges, Addison Whitney leveraged the equity of the Olive Garden name and created a more sophisticated script lettering in a modern font.

The creation of an icon to complement the Olive Garden's new look involved Olive Garden employee and customer research. Several icons were tested; the warm feel and vibrant colors of the grapes were a consistent favorite. The grape design reflects the new wine service and attracts a more sophisticated target audience while maintaining a fresh, wholesome look that appeals to family-oriented customers. The distinctive grape icon was implemented on signage, menus, placemats, take-out items, and promotional materials, and serves as a memorable, stand-alone symbol for the restaurant chain.

client
Olive Garden
design firm
Addison Whitney
Charlotte, NC

A company that was born in the 1980s needed an update to its original identity. With a desire to serve its own brand better, Icon set out to redesign its logo to be more contemporary, and less trendy, while giving a better representation of the quality of service provided.

client
Icon Graphics
design firm
Icon Graphics
Rochester, NY

Broadway Computer, a technology retailer ready to launch their Web store, asked us to redesign their logo. The challenge here was to integrate the name, tagline, and a new design element to function as one cohesive unit.

TECHNOLOGY ON THE GOSM

Broadway *Computer*®

& VIDEO

client
Broadway Computer
design firm
Rappy & Company
New York, NY

Chetti Landscaping started out as a small operation and grew into a multi-seasonal, full-service landscaping company. The original logo was your standard do-it-yourself, small-business, desktop-publisher design. We needed to make Chetti Landscaping look as professional as they had become. This meant a bold, strong typeface for lawn signs, an easily adaptable logo for one-color flyers, and a simple, natural graphic element to represent landscaping.

client
Chetti Landscaping
design firm
The Star Group
Cherry Hill, NJ

Sayles Graphic Design recently created a new logo for Jordan Motors, a specialty and import auto dealership in Des Moines. The original logo featured black, sans serif type inside a red ring on a white background. Designer John Sayles kept the minimal style of the logo, but elaborated on the design with white, hand-rendered type reversed out from a red oval background. A second outline of red color, broken by the "J" and the "N" of Jordan, completes the design. The result is a simple, yet sophisticated logo fit for the prestigious dealership.

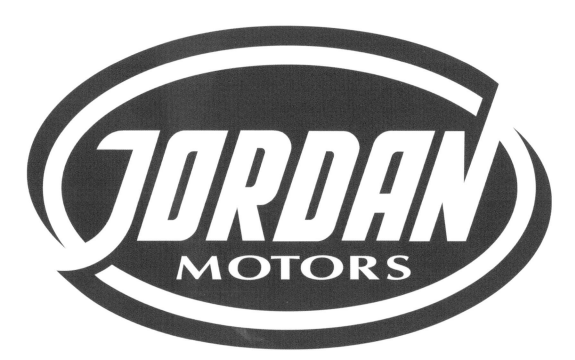

client
Jordan Motors
design firm
Sayles Graphic Design
Des Moines, IA

The athletics department at Drexel University had the same problem that countless other university athletic programs share…an outdated logo. The old Drexel Dragon logo was one of the many "walking mascot" marks that had been created decades ago when "cute" was the fashion for collegiate mascots. In today's marketplace (not to mention on today's field of play) "cute" just doesn't cut it anymore. Drexel wanted a fierce, fire-breathing mascot that was ready to strike fear in the hearts of its opponents, and this new logo delivered just that.

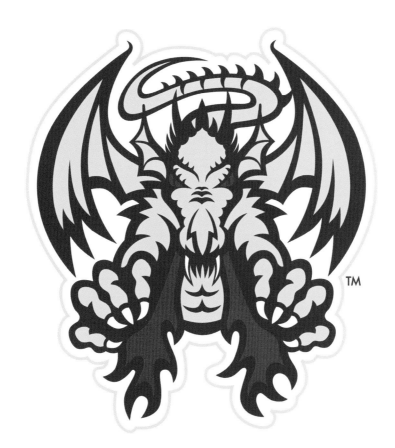

client
Drexel University
design firm
Rickabaugh Graphics
Gahanna, OH

Establishing a new professional image with a simple, yet strong symbol was required. The contemporary look is designed to showcase that Momentum has the ability to initiate, create, and establish strong marketing and branding skills. Two letter forms are combined in a dynamic symbol that can be carried throughout all of their marketing materials.

client
Momentum Group
design firm
Sullivan Marketing
Phoenix, AZ

Designer John Sayles recently jumped at the chance to redesign the logo for a local Harley Davidson motorcycle shop.

Zook's Harley Davidson approached Sayles Graphic Design to take its Route 65 logo to the next level. The original logo was black and white, with the name of the shop in a basic serif typeface enclosed in the outline of an interstate highway sign. Sayles added stylized, hand-rendered type, and a detailed flame design around the outline of the road sign. Bright red, orange, and blue, accented with black and white, brought the logo to life.

client
Zook's Harley Davidson
design firm
Sayles Graphic Design
Des Moines, IA

THE CANTOR SEINUK GROUP INC.

Cantor Seinuk, a 35-year-old, structural engineering firm, came to us with their original logo and asked us to bring it up-to-date. Although their name had recognition in the industry, they wanted to modify it by dropping the "group" and casting Seinuk as the dominant name. We suggested adding a tagline to communicate their expertise. We kept remnants of their icon but successfully brought it into the 21st century.

Cantor SEINUK
STRUCTURAL ENGINEERS

client
Cantor Seinuk
design firm
Rappy & Company
New York, NY

The look of Brownstone's image must suggest style and workmanship in all areas of construction.

The new logo uses natural colors with an indication of the intricate details of craftsmanship that goes into everything they build. Sophisticated and elegant use of the logotype emphasizes and enhances that look and gives them a more quality appearance. The creative approach of using the "Michelangelo" style of showcasing the arches, circles, and symmetry of the symbol all suggest quality designs.

client
Brownstone Residential
design firm
Sullivan Marketing
Phoenix, Arizona

When your old logo is a piece of clip art there is an obvious need for a new identity, and with an inspiring name like "Rattlers," it would be a shame to create anything less than an intimidating visual. The new athletic brand is a combination of a "ready to strike" rattler in green and orange with a new wordmark design that even seems to have fangs of its own. This new mark can't help but stand out and produce increased licensing income.

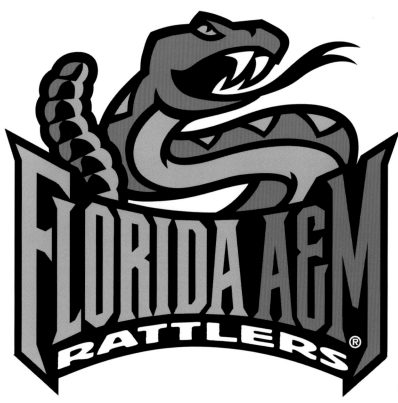

client
Florida A&M University
design firm
Rickabaugh Graphics
Gahanna, OH

The traditional cooking pot of steaming curries is made of the letters "M C H"—the acronym for the restaurant. This cooking pot also creates an immediate association with food.

client
Maju Curry House
design firm
TrueFaces Creation
Selangor, Malaysia

Hayes Management focuses exclusively on healthcare consulting. The company provides business, clinical, and IT consulting to physician groups, HMOs, hospitals, clinics, and academic medical centers.

The old logo was difficult to reproduce and to read. The brand was unclear and the use of the triangle and stripes confusing.

The new logo clearly brands "Hayes." The colors reflect healthcare. The interlocking "H" represents the partnership that Hayes has with its clients as well as an oblique referral to the "H" for hospital.

HAYES
MANAGEMENT
CONSULTING

client
Hayes Management Consulting
design firm
Fassino Design
Waltham, MA

philadanco

Philadanco had no distinctive logo per se. They just used a typeface. It just "sat there." It did not reflect the spirit of Philadanco.

This 35-year-old dance company is one of the most talented, exuberant performing arts group in Philadelphia, with international acclaim. They are known for their high-spirited, energetic talents—quoted by the Village Voice as "Performers whose blazing physicality and commitment light up the stage."

In the new logo, which I designed over 10 years ago for their 25th anniversary, I used typography alone to express the highly creative, energetic power of this dance company. The hand-brushed letterforms dance across the page, filled the liveliness and vigor of this dance group. We also decided to put an exclamation point at the end of the name to punctuate the excitement reflected in the logotype.

client
Philadanco
design firm
Randi Wolf
Glassboro, NJ

Brinker International approached Addison Whitney to aid in the repositioning of On The Border Mexican Grill to differentiate it from the Tex-Mex image of Chili's, a sister restaurant. Previous customer response to testing of new restaurant interiors strongly supported a new, fun, fiesta atmosphere concept. This lighthearted image was the basis for the new visual brand, which would serve as the cornerstone of the new identity for On The Border Mexican Grill.

Utilizing customer awareness and perception research of On The Border, Addison Whitney identified that the "sawtooth" design and the arched logo possessed positive brand equity. Following a structured creative development and research process, Addison Whitney developed an award-winning design which incorporates the sawtooth arch and associated vibrant colors. The lime wedge adds another fun element and immediately conveys authentic Mexican food and beverages, such as Margaritas. The consistency of the colors and the sawtooth design are carried throughout the architecture and interior design of the new restaurants, further building the new brand identity.

client
On the Border
design firm
Addison Whitney
Charlotte, NC

SitOnIt hired us to overhaul a corporate image that did not reflect their corporate personality, offering, or wild success in the mid-market contract furniture industry. We developed a new mark that reflected the new grown-up SOI. Of course they make chairs, so an abstract chair made perfect sense.

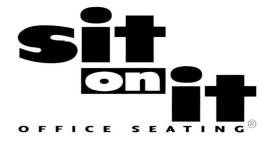

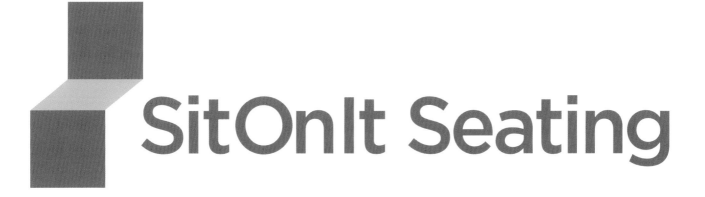

client
SitOnIt Seating
design firm
BBK Studio
Grand Rapids, MI

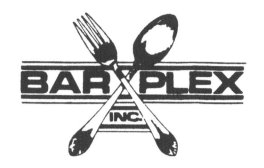

Bar-Plex, a restaurant supplier and kitchen designer, engaged Rappy & Company to give them a new look. We assessed their current logo and decided to keep the font, but eliminate the tedious fork and spoon illustration. We brought the name together as one word, separated it by color, and enclosed it in an ellipse, resembling a nameplate. We then created a stronger image by introducing rules to suggest an architect's drawing.

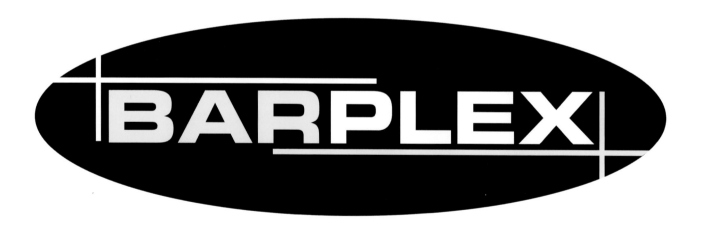

client
Bar-Plex
design firm
Rappy & Company
New York, NY

The old logos for Idaho State athletics were mainly a variation of other school's logos. What they wanted in their new identity was a dynamic Bengal tiger graphic combined with a unique type design. From over a dozen concepts, they chose a very fierce, snarling tiger head and a wordmark full of claw marks. The combination was exactly what they were looking for.

client
Idaho State University
design firm
Rickabaugh Graphics
Gahanna, OH

A multinational company specializing in design, supply, and commissioning of edible oil refineries, Lipico Technologies needed an overhaul of their brand identity to herald a new corporate direction in making them even more customer- and people-centric.

Shaped like an oil-drop, the fluidity of the new logo serves to symbolize Lipico as always moving and evolving, redefining and reinventing to meet the industry's needs. Green, the color of life and nature represents Lipico's deep-rooted belief in benefiting the community by being environmentally-friendly. The juxtaposition of the free form oil-drop and the bold typeface beautifully renders balance to the mark.

Through this creative execution, a new zeal was breathed into the identity, strongly bringing forth the essence of the business, and creating a dynamically fresh energy that exemplifies the company's philosophy.

client
Lipico
design firm
Ukulele Brand Consultants
Singapore

The old logo for these ophthalmic cosmetic surgeons' practice consisted of an abstract symbol of a laser pointing at the eye area of a face, inside a gray rounded cornered square. Although these eye specialists do laser cosmetic surgery around the eye, they do not do "Lasik" surgery which is used for vision correction. This makes the original logo a bit ambivalent to their clientele.

In redesigning their new logo, the client wanted to concentrate on the cosmetic "beauty" aspect of their practice, yet they wanted to tie-in the new logo to the older one in some way. This was achieved by using the same color for the symbol and the same elegant typography for the doctors' names. The doctors also decided to give their practice a "name"—The Center for Aesthetic Skin Care" which encircles a simple-shaped swan, a symbol of beauty. The contour of the swan on the gray background shape is reminiscent of the contour of the face on the old logo. Yet the oval shape in the new logo has an embossed look, giving it some depth and more visual interest.

Marc S. Cohen, MD, FACS
Nancy G. Swartz, MD
Ophthalmic Plastic and Cosmetic Surgeons

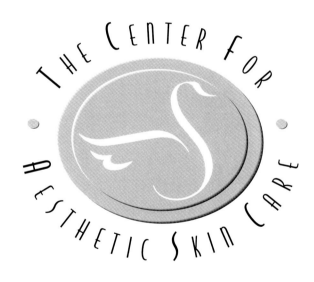

Marc S. Cohen, MD, FACS • Nancy G. Swartz, MS, MD, FACS
Ophthalmic Plastic and Cosmetic Surgeons

client
The Center for Aesthetic Skin Care
design firm
Randi Wolf
Glassboro, NJ

Beth Israel Deaconess Medical Center sold the Deaconess Nashoba Hospital to Essent Healthcare in the Spring of 2003. At that time, the hospital consisted of 40 beds and outdated equipment.

In creating a new identity for the hospital, we needed to make sure that the people of the area knew the hospital was changing for the better—keeping its location, but investing in new technology and personnel.

The new logo and tagline convey the expertise that is available at the hospital portraying it as a first-class medical institution.

Where Excellence is Essential

client
Nashoba Valley Medical Center
design firm
Fassino Design
Waltham, MA

The athletics department at Old Dominion was in desperate need of a new look. Due to the lack of an acceptable athletics identity, they had been simply using the university's logo to represent their sports teams. They all knew that they wanted an energized lion with a crown, and they asked us to show them how that could look. The chosen design features an intimidating image of the king of the jungle, incorporating the traditional ODU crown perched on his head. We also brought back Columbia Blue as an accent color (a hue that the alumni had been missing since it was abandoned in favor of navy and silver 10 years earlier).

OLD DOMINION UNIVERSITY

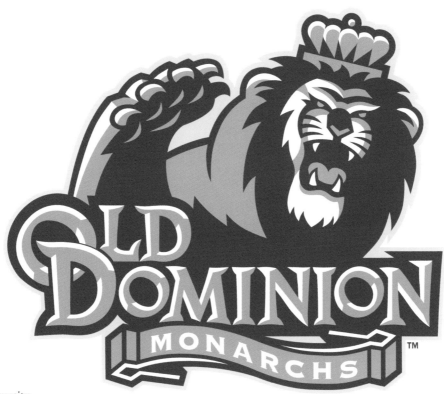

client
Old Dominion University
design firm
Rickabaugh Graphics
Gahanna, OH

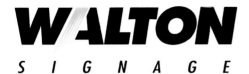

Walton Signage is a long-established, midsize signage company based in Texas. The objective was to create an updated corporate identity to attract larger clientele on a national and international level. It was important to the client that this new identity reflect their three-generation history. This was accomplished by utilizing portions of signs they had built over the years to create their own identity. Hence the consistent use of the "W" shown in various forms of signage.

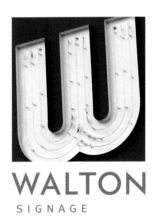

WALTON
SIGNAGE

WALTON
SIGNAGE

WALTON
SIGNAGE

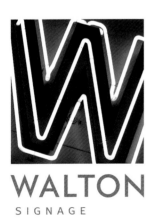

WALTON
SIGNAGE

WALTON
SIGNAGE

client
Walton Signage
design firm
Bradford Lawton Design Group
San Antonio, TX

Dan's
Food Service

LPG Design had the opportunity to create a new identity program for Dan's Food Service. We felt the old, simple logo could use a much-needed update with a new hand-drawn approach. The newly-designed logo has flowing waves, rolling fields, and bursting rays. All elements were brought together creating a soft, homegrown feeling, for a company who delivers to family restaurants and suppliers.

client
Dan's Food Service
design firm
LPG Design
Wichita, KS

Our job was to design new graphics using an ownable green herald that is reminiscent of a country sign and creates a billboard effect on the shelf. We incorporated vibrant fruit graphics to enhance shoppability while conveying the brand as fresh, flavorful, genuine, and down-to-earth.

client
Old Orchard
design firm
The Bailey Group
Plymouth Meeting, PA

Dealing in disc brakes and brake shoes, the FBK name is manipulated to look like a wheel base with the "B" containing a ball-like object to symbolize a disc brake. Bright colors give it a cheerful feel for an otherwise staid mechanical product.

client
FBK Systems
design firm
TrueFaces Creation
Selangor, Malaysia

Fulfilling two objectives, the company name "EIA" is incorporated into the logo, with the "I" as the centerpiece that connects the "E" and "A". Blue and green are used to depict the environment which is the sphere of consultation for the company.

PERUNDING EIA (No. 958312-A)
CIVIL, STRUCTURAL & ENVIRONMENTAL
CONSULTING ENGINEERS

PERUNDING EIA

client
EIA
design firm
TrueFaces Creation
Selangor, Malaysia

The logo assignment was to develop a distinctive symbol that would commemorate the 150th Anniversary of Thomas Edison. The final logo would be used on all U.S. Parks Commission promotions and signage for one year.

The old logo attempt, done internally by the client, was not approved, thereby allowing our design team an opportunity to solve the problem. After researching the many inventions created by Thomas Edison, from the phonograph to the first reinforced concrete house, it was determined that the light bulb would be the invention most attributed to him. The new logo approved by the client combines Edison's facial profile with that of a light bulb. This image successfully unites the inventor with his most significant invention. The entire symbol is encased in a square that has a negative/positive background with rays emanating from the bulb, further emphasizing the concept of light. The new logo can be adapted to a future postage stamp and additional promotional events.

client
U.S. Parks Commission
design firm
Stephen Longo
Design Associates
West Orange, NJ

Pomco Graphic Arts, a very large and well-respected commercial printer in Philadelphia, wanted to dramatically update their long-established corporate identity, as a way to mark their entry into the 21st century. Their old logo fit together like a typographic puzzle, and although interesting in its own right, it did not reflect Pomco's modern and forward-moving approach.

The new logo incorporates clean, modernistic typography, replacing the first "O" with a symbol of a swirling orb. This orb symbolizes the many facets of the business, including the motion of the printing press and the company's technological savvy and diverse capabilities. The words "Graphic Arts" visually move to the right like paper feeding off the press. The bronze color symbolizes Pomco's vision of a glowing future, while the conservative navy blue recalls the company's proud history of outstanding craftsmanship and service.

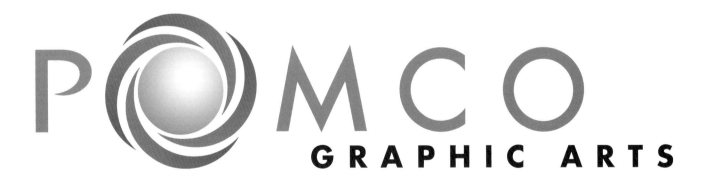

client
Pomco Graphic Arts
design firm
Randi Wolf
Glassboro, NJ

PC Assistance, Inc., needed an updated logo to replace the outdated floppy disk graphic. The PC graphic shows integration, innovation, movement, and depth which is indicative of the company's many areas of technical expertise.

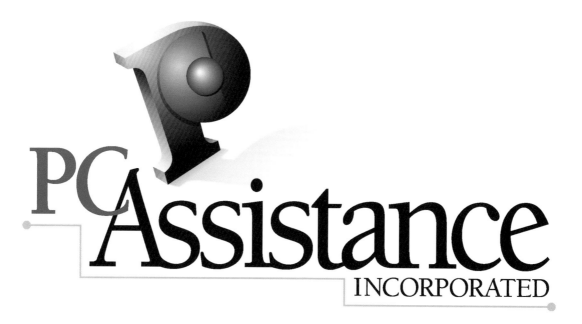

client
PC Assistance
design firm
McElveney & Palozzi
Rochester, NY

The old athletics logo at Seton Hall featured a sketchy drawing of a pirate with a dagger in his teeth. Obviously this was not the most politically correct image for New Jersey's largest Catholic university. They asked us to develop a more symbolic and less threatening pirate image. The final pirate design was selected from over 30 concepts and then combined with a custom type font. We also convinced them to add silver to their traditional palette of blue and white. This new color combination helps greatly to separate them from the multitude of other blue and white teams.

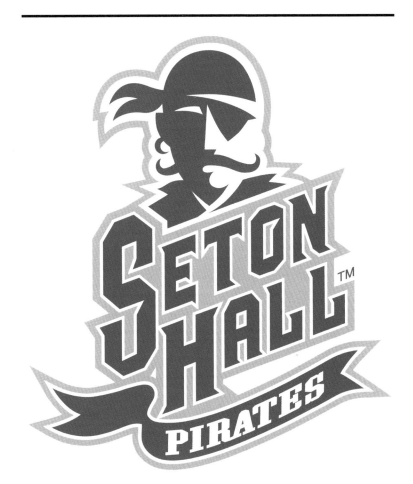

client
Seton Hall University
design firm
Rickabaugh Graphics
Gahanna, OH

When Des Moines-based Pinnacle Food Group approached Sayles Graphic Design to create a new logo for their Rosewood Farms brand of pork products, the design team taste-tested product samples for inspiration.

Designer John Sayles wanted to maintain the integrity of the brand's existing logo, a three-color farm landscape enclosed in a red ellipse with the Rosewood Farms name in a script typeface above. Sayles kept the same red, black, and green color scheme and the overall elliptical shape, but updated the design by drawing attention to the brand name with a bold serif typeface reversed out of blocks of black and red color. The farm scene was simplified to include only a stylized barn and silo with the initials "R.F." evident in the design.

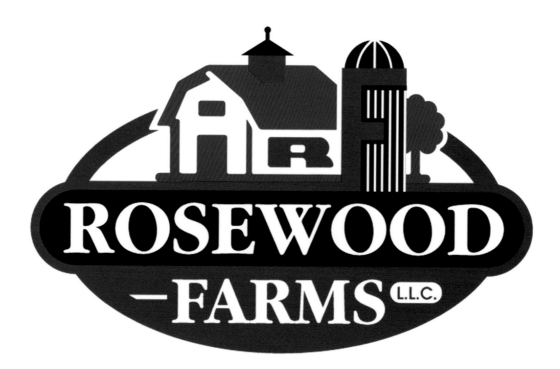

client
Pinnacle Foods Group
design firm
Sayles Graphic Design
Des Moines, IA

The AIA is the governing body for all high school sports and activities in the state of Arizona. Despite their small budgets, the concept is to make them have a more dominant appearance because of who they are. The new look for the logo should immediately convey that it is Arizona, and add a more dynamic feel to their image. Showcasing the state flag with a three-dimensional look to the star and logotype in the symbol communicates energy and visually conveys a more contemporary positioning.

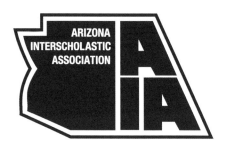

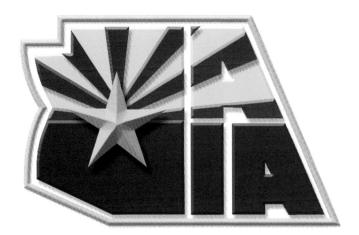

Arizona Interscholastic Association, Inc.

client
Arizona Interscholastic Association
design firm
Sullivan Marketing
Phoenix, AZ

Woodside Square is a Community Shopping Mall. The 35-year-old mall was undergoing a much-needed, massive redevelopment. A new logo was planned to launch with the newly renovated mall.

The new logo was designed with an offset keyline square, conveying a sense of energy, against a solid square, representing a strong foundation in the community. The mix of a traditional serif font and a more contemporary sans serif was aimed at suggesting a balance between the old and the new. PMS 287 blue was chosen to be seen by the consumer as reliable and trustworthy while the energetic PMS 389 green was used to say new and fresh.

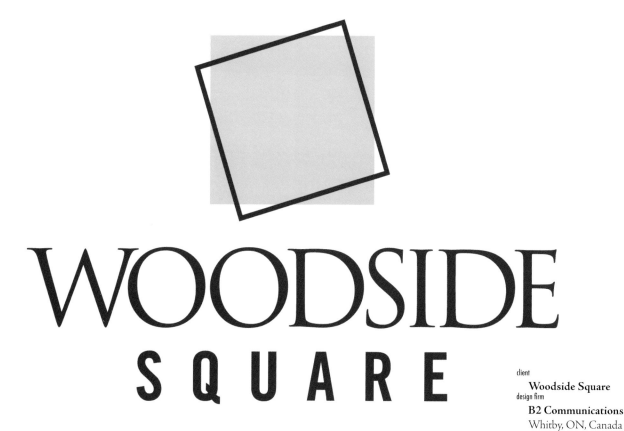

client
Woodside Square
design firm
B2 Communications
Whitby, ON, Canada

After designing the logos for each Iowa State Fair event since 1997, Sayles Graphic Design has given the organization a new corporate logo that effectively communicates the historic tradition of the fair in a timeless style.

In developing the new visual, designer John Sayles instantly identified the blue ribbon as one of the most recognized symbols of the Iowa State Fair. He incorporated layers of primary colors around a stylized ribbon, and wove the monogram ISF into the graphic as well.

"The update is more than just a new logo," says Iowa State Fair Marketing Director Kathie Swift. "The previous Iowa State Fair corporate logo was designed in 1977 and was chosen to represent Iowans from all four corners of the state coming together to celebrate the four elements of the fair: education, competition, recreation, and entertainment." While these ideals still are prevalent, the "quadracom" shape, as it was known, didn't immediately convey a clear image of the Fair.

client
Iowa State Fair
design firm
Sayles Graphic Design
Des Moines, IA

For many years, the University of Connecticut athletic teams had been represented by a detailed sketch of a friendly, white Husky dog. This image was dearly-loved, but nearly impossible for the creators of their apparel to reproduce. UConn asked us to modernize the traditional Husky dog with a bolder simpler design. We then combined this revitalized Husky design with a custom font especially created for the UConn teams.

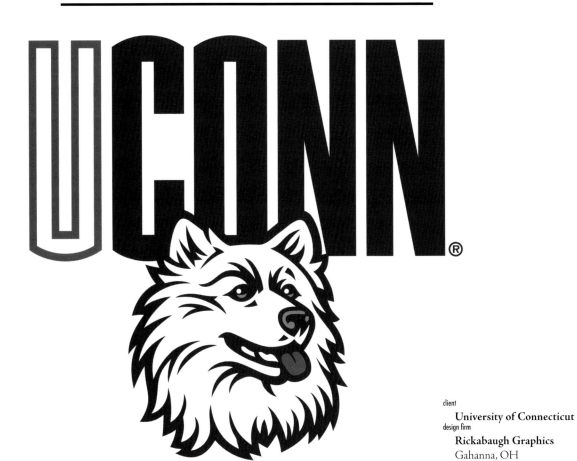

client
University of Connecticut
design firm
Rickabaugh Graphics
Gahanna, OH

It always presents a challenge when a design firm decides to revise its logo and image. After many years of use, we decided it was time to update our logo. The old logo was distinctive but needed a more contemporary image. Playing to the uniqueness of the name "Longo", the accent mark was retained over the letter "o" and both type elements were made to break the confines of the square, suggesting the feeling of spontaneity that we desired.

This spontaneity was reinforced by the use of a brushstroke effect accomplished with a dry marker on textured paper. The selected logo was then scanned and colored.

Stephen Longo & Associates

client
Stephen Longo Design Associates
design firm
Stephen Longo Design Associates
West Orange, NJ

After 15 years in the avocado business, the Rivas brothers were now exporting to Japan and Europe, and they needed a new, global approach in their visual image. They changed the company name to "Global Frut", and since our firm had been taking care of their packaging design for some time the next step was to develop a new logo.

How can you represent their "Global" and "Fruit" concepts in one image? Here is the answer: the avocado lays in a "Globe" and its seed turns into a satellite, with an orbit and everything!

client
Global Frut
design firm
Kenneth Diseño
Uruapan, Mexico

Ernstmann Machine Co. Inc. had an outdated logo that did not represent the company well. Their original logo had a weak and computerized feel, which is not what Ernstmann Machine is. They are a strong, industrial company that mills and threads a variety of machine parts for major manufacturers. We created a bold, machined logo that would gear people to understand what the company does.

client
Ernstmann Machine Company Inc.
design firm
LPG Design
Wichita, KS

To increase relevancy to teens without losing their all-family appeal, Kellogg's Rice Krispies Treats required a refreshening of their brand identity. Contemporary branding is achieved via a dynamic evolution of the brand heritage. The beloved Snap Krackle and Pop are locked into the logo and given a new "icon" status. The revitalized logotype creates an active, energized look at retail.

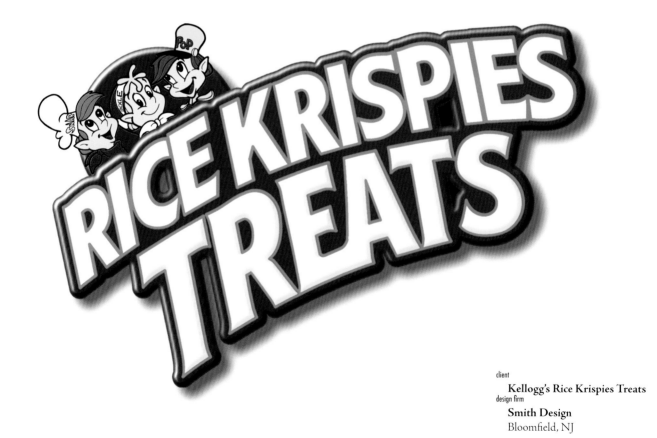

client
Kellogg's Rice Krispies Treats
design firm
Smith Design
Bloomfield, NJ

An illustrated bird, formed by the letters "Y S," piercing through its triangular confines depicts a surge forward—a victory—the meaning of which was encapsulated in its original Chinese calligraphic logo.

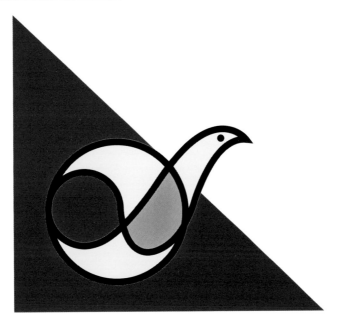

赢 双 贸 易 公 司

Ying Shuang Trading

client
Ying Shuang Trading
design firm
TrueFaces Creation
Selangor, Malaysia

The new logo was designed to emphasize the uniqueness of a fusion restaurant and its contemporary menu appeal. The old logo did not exhibit these qualities and utilized a computer typeface that was generic in look. We developed a logotype that would represent a "fusion" concept, whereby Asian food and other distinctive menus could be served within the same restaurant. The new logo can fit into many food categories without being solely Asian and has an eclectic appeal. Current customers are surprised by the various items on the menu that change daily and like the contemporary identity. The stylized "k" letterforms that extend upward beyond the frame give a positive reinforcement to this contemporary image. Color was explored and developed to be distinctive and highly effective when applied to signage, packaging, stationery, and vehicle graphics.

client
Ekko Fusion Restaurant
design firm
Stephen Longo Design Associates
West Orange, NJ

Johnson & Johnson wanted a new brand identity that supported the development of unparalleled, science-based, and technology-driven healing solutions. We developed a logotype that reinforces customer connectivity, innovation, and standardization in global wound care. The logo clearly balances the equity of "Johnson & Johnson" with the constant innovation and technological advancement that is the commitment of this company.

client
Johnson & Johnson
design firm
The Bailey Group
Plymouth Meeting, PA

The objectives for the logo's redesign were to make a bold, new statement about Skippy as the brand that owns "fun," and to build on the brand's existing visual equities (such as color and typography style) for instant consumer recognition. The new typography is a more energetic, playful, and bouncy evolution of the logotype. Overall, it is a more vibrant, lively, and contemporary approach.

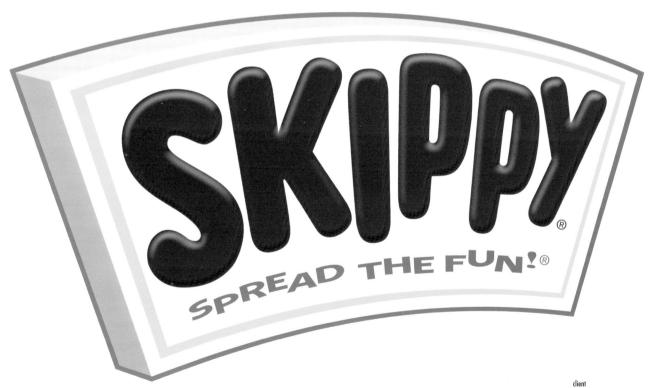

client
Skippy
design firm
Smith Design
Bloomfield, NJ

The old logo at USD was simply a photo of a coyote's eyes. It was a powerful image, but difficult to reproduce in embroidery and screen printing. We designed a new, intimidating coyote mascot for them and paired it with a new type design (the coyote is also available as a head only version and a howling version). In order to maintain consistency with the university's identity we incorporated the "U." designation in front of the "South Dakota" wording. Our company added the light gray as an accent color to complement the traditional red and black combination.

client
University of South Dakota
design firm
Rickabaugh Graphics
Gahanna, OH

A leaf-like icon was designed to give the overall logo a blooming character-istic as this company deals in venture capital investments. The connotation is that whatever investments are made will blossom and grow.

client
Netval
design firm
TrueFaces Creation
Selangor, Malaysia

The original Matsuya logo was a script typeface that was computer-generated by the owner. After researching Japanese restaurants in Japan and in the United States, our design team created a new image that incorporated a logotype reminiscent of bamboo and a parchment scroll influenced by traditional Japanese forms. Color schemes were explored and developed that reflected those found within Asian cultures. The name "Matsuya" was derived from the words pine tree, and a pine tree symbol was added to further define the name. The fish and graphic devices on the scroll were also used creatively in various forms on a total of five menus: the Sushi Menu, Main Menu, Lunch Menu, Bar Menu, and Children's Menu to unify the identity.

client
Matsuya Japanese Steak House
design firm
Stephen Longo Design Associates
West Orange, NJ

McElveney & Palozzi
GRAPHIC DESIGN GROUP

A bolder statement was established with the design of the principals' initials being developed into an integrated letterform graphic. This, along with a fresh, new color palette marked the businesses incorporation.

McElveney & Palozzi
D E S I G N G R O U P I N C.

client
McElveney & Palozzi
design firm
McElveney & Palozzi
Rochester, NY

Nitro Bits came to LPG Design to create their new drill bit packaging. After speaking with the client about the product, we convinced them to let us redo their logo to better represent the product. The product is an expensive top-of-the-line drill bit that is cryogenically processed. This hardens the metal, and makes it one of the few drill bits that could conquer just about any task. With this in mind, we decided the polar bear logo needed to be deemphasized in order to keep people from being mislead about the product. The colors chosen were to create a dominant and solid-gold feeling. We also strengthened the typeface, all of which created "Nitro Bits" new and bolder logo.

client
Nitro Bits
design firm
LPG Design
Wichita, KS

The University of Wisconsin's Bucky Badger logo had been in existence for more than 50 years with little change. The university won a federal court case in 1994 to register the Bucky Badger logo, but local businesses that had previously been using the logo for years were "grandfathered in" to continue using the image. By asking Rickabaugh Graphics to create an updated look for Bucky (along with an accompanying new logotype design), the university was able to clearly distinguish between the old and new Bucky designs. Anyone caught using the new and very popular Bucky without permission could be prosecuted to the full extent of the law. The new Bucky character sports the current "Motion W" on its chest and is also is available in a "head only" version. In addition, the cleaner and better defined lines of the new logo make it much easier for their vendors to to reproduce the art successfully.

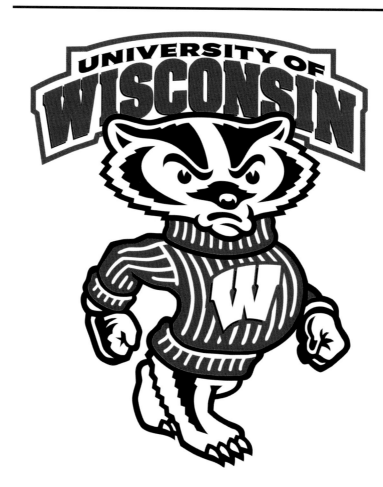

client
University of Wisconsin
design firm
Rickabaugh Graphics
Gahanna, OH

This responsive, customer focused organization needed to communicate their unmatched experience and expertise in the high-flex, short run, electronic assembly industry. Dominant typography and graphics suggesting energy, agility, and innovation were employed to achieve the identity revitalization.

client
Badger Technologies
design firm
McElveney & Palozzi
Rochester, NY

GYNECARE

The objective in creating a new Gynecare logo was to establish Gynecare as the brand passionately committed to transforming women's health. Gynecare is pursuing and delivering innovative solutions that truly transform women's health and help physicians improve the standard of care for woman. The tone of this logo is optimistic, credible, insightful, and speaks woman to woman.

Gynecare
WOMEN'S HEALTH SOLUTIONS

client
Gynecare
design firm
The Bailey Group
Plymouth Meeting, PA

EL PEDAL DE ORO

After more than 30 years in the business, this successful bicycle retail and repair shop faced new competition from out of town. They had three shops, but needed to unify their visual image.

The new logo, a high impact, eye-catching design is used in outdoor signs, facade decoration, uniforms, and vehicles. The name was shortened from "El pedal de oro" (the golden pedal) to "EL Pedal" which is also the nickname of the owner.

client
El Pedal
design firm
Kenneth Diseño
Uruapan, Mexico

BAE is a direct marketing company dealing in aura energy products. To give it a scientific look, the atom forms the core of the logo. The three letters "BAE" are rendered in an abstract and contemporary format.

client
BAE
design firm
TrueFaces Creation
Selangor, Malaysia

Worldgreen is a leader in integrated shipping and airfreight solutions. The major brand identity revamp of Worldgreen revolved around the concept of constant movement. Ukulele made it a point to focus on the very nature of Worldgreen's business, and thereafter creatively communicate it through an artistic rendition of three ripple effects morphing into a bird soaring above and beyond. The varying lengths and fluidity of the ripples articulate the experience of dedication, service excellence, and growth that Worldgreen excels in and also constantly pursues to achieve for its clientele.

client
Worldgreen
design firm
Ukulele Brand Consultants
Singapore

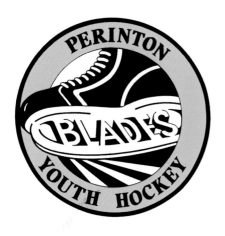

After 14 years, the Perinton Youth Hockey Board of Directors decided that it was time to upgrade their look, to be better aligned with the quality of their programs and player development initiatives. The new logo was intended to maintain the traditional black and gold color scheme, but re-interpret "Blades" in a look with which players can really identify. Since its debut, enrollment is up, and youth hockey players have graphic advantage every time they hit the ice.

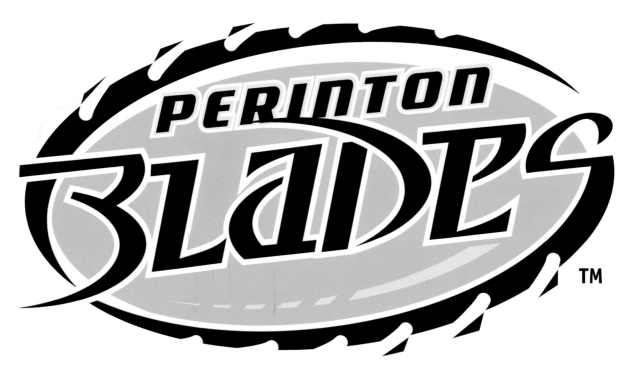

client
Perinton Blades
design firm
Icon Graphics
Rochester, NY

The challenge was to bring freshness and excitement to the Frigo brand. As a brand with a strong heritage, it was important to maintain the tones of the old design while at the same time making it youthful, fresh, and relevant to today's consumers. The new look speaks to fast, fresh, and convenient meal solutions. A swashy, brush style type and graphic elements communicate a new energy, plus the new identity is a better fit to Frigo's premium quality product line.

client
Frigo
design firm
Smith Design
Bloomfield, NJ

After 10 years in operation, the Foundation determined that it had virtually no brand recognition with the existing logo.

The new logo evolved from the Foundation's new positioning statement, "If you want oak trees, you have to plant acorns," and reflects the growth opportunities provided to the students by the Foundation funding.

LITTLETON PUBLIC SCHOOLS FOUNDATION

If You Want Oak Trees, You Have To Plant Acorns

client
Littleton Public School Foundation
design firm
Hat Trick Creative
Littleton, CO

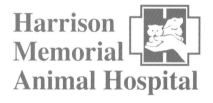

Harrison needed a fresh brand image—logo and positioning statement—for its animal hospital services.

The old, dated logo looked very similar to many other veterinary medicine providers in the area. Also, it didn't convey to the pet owner the feeling of joy and satisfaction when a healed, healthy pet was returned.

The new logo and the positioning statement "Giving pets a new leash on life" meets these needs.

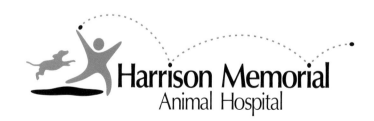

client
Harrison Memorial Animal Hospital
design firm
Hat Trick Creative
Littleton, CO

The old Xavier athletics logo featured a silhouette of a musketeer dribbling a basketball down a court, a great logo for the basketball team but not quite right for the baseball team. The university asked us to create both a simple and clean musketeer design along with a custom type design. We did just that, adding a touch of silver to the traditional blue and white color scheme.

client
Xavier University
design firm
Rickabaugh Graphics
Gahanna, OH

GROUND

zerø

Following the 9-11 disaster, one of Hornall Anderson's clients, Ground Zero, felt it was prudent to change the name of their company—a manufacturer of cardio and strength training equipment. As a means of reflecting their business, the client became FreeMotion, a play on the idea behind the fitness equipment.

FREE▮OTION™

client
FreeMotion
design firm
Hornall Anderson Design Works
Seattle, WA

TrueFaces is a design and creative consultancy.

The square logo is an abstract representation of a face. Shaped in uneven geometry, it is a fluid design suggesting versatility and innovation. The face lends a human touch to the scope of its business.

client
TrueFaces Creation
design firm
TrueFaces Creation
Selangor, Malaysia

APEAM A.C.
Asociación de Productores y Empacadores
Exportadores de Aguacate de Michoacán A.C.

APEAM is the avocado grower, packer, and export association in Mexico. Its more-than 1000 associates get certification from USDA so they can export their product to the USA market. Their old "logo" depicted a confusing map showing the export route.

The new logo is a contemporary image of an avocado aiming to the north, based on a bold type representing a solid institution, using the three colors of the avocado: dark green, light green, and maroon. The logo is widely used in signs, stationary, vehicles, uniforms, web page, stands, etc.

client
Apeam
design firm
Kenneth Diseño
Uruapan, Mexico

Aetna wanted a new corporate identity to reflect its member-centric philosophy and programs, as well as its focus on preventive care. We chose to design a logo that conveys empowerment, accessibility, and choice.

client
Aetna
design firm
The Bailey Group
Plymouth Meeting, PA

Cultures is a quick service, fresh food restaurant chain. Their market are young professionals seeking a healthier lunch alternative to fast food.

We designed a new logo and positioning line to help revitalize the 30-year-old chain. The "body c" icon was developed to project a younger, more energetic, healthier feel. Bodega was chosen as the new logo font to give it a more sophisticated appeal. The PMS 341 green emphasizes freshness.

client
Cultures Restaurants
design firm
B2 Communications
Whitby, ON, Canada

RynoSkin is an insect body armor that protects you from chiggers, ticks, and most biting insects. When we spruced up their existing logo, we felt the logo should reflect this thin body suit. We kept the logo's circular feel, but enclosed all the words to make it look like one bold icon and not just a logo with type. We simplified the rhino, primarily using just a silhouette of the head, and "peeled" the skin of the logo to give it that second-skin feeling.

client
Rynoskin
design firm
LPG Design
Wichita, KS

distribuidora de
productos alimenticios

Delicat is a small company dedicated to the distribution of fine cheeses and meats to hotels and restaurants. It is totally committed to quality and good service. Their old logo was too technical and cold. It did not represent a company in the food business.

The new logo combines abstract images of meat and cheese, shining with quality inside an ascendant letter "D." We presented only this design to the client (no other options) because we knew it had everything a good logo needs: visual impact, uniqueness, aesthetics, symbolism, legibility…they were very pleased with the result.

DELICAT

client
Delicat
design firm
Kenneth Diseño
Uruapan, Mexico

Index

About the Author

David E. Carter is the bestselling author/editor in the history of graphic design books.

In 1972, when there were **no** logo design books available, Carter produced *The Book of American Trade Marks, Volume 1.* (Seventeen publishers rejected that book before it was published; it went on to become one of the bestselling graphic books ever.) To date, he has written or edited over 100 books on the topic of corporate identity.

By 1978, Carter had produced 10 books related to corporate image; that year, he conducted seminars for *Advertising Age* in New York, Chicago, and Los Angeles. His corporate identity seminars eventually expanded around the world to locations such as São Paulo, Brazil, Helsinki, Finland, and Singapore.

In 1989, Carter established a major presence in Asia as a design consultant. Through affiliate offices in Bangkok and Jakarta, he managed identity projects for a large number of multinational firms in the Pacific Rim.

While corporate identity is Carter's specialty, he has had a variety of other business interests. In 1977, he

©1999 by Al Hirschfeld. Drawing reproduced by special arrangement with Hirschfeld's exclusive representative, The Margo Feiden Galleries, Ltd., New York.

founded an advertising agency that soon qualified for AAAA membership. He wrote and produced an ad that won a Clio Award in 1980. In 1982, he started a TV production company and won seven Emmy Awards for creating innovative programs that appeared on PBS. He also produced a large number of comedy segments which appeared on *The Tonight Show Starring Johnny Carson.*

His first book for general audiences, *Dog Owner's Manual*, is a humorous book and was published in the spring of 2001 by Andrews McMeel.

Currently, he is working on several new corporate identity books, as well as editing the annuals, *American Corporate Identity* and *Creativity.*

Carter worked his way through school, earning an undergraduate degree in advertising from the University of Kentucky, and holds a master's degree from the Ohio University School of Journalism. More recently, Carter returned to the classroom to earn an MBA from Syracuse University in 1995. He graduated from the three-year Owner/President Management program (OPM) at the Harvard Business School in 1998.